IMAGES
of America

PENNHURST STATE
SCHOOL AND HOSPITAL

ERIC—
BEST WISHES!

Jim Conroy

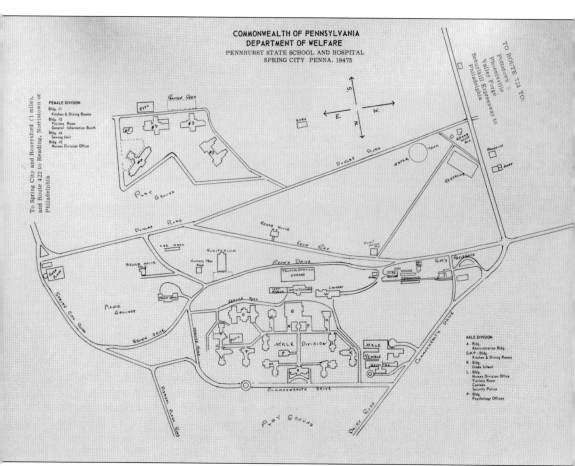

This campus map dates from 1967. It was included in the "Progress and Careers at Pennhurst" recruitment pamphlet designed to attract new employees, as demonstrated by the directions to nearby (and not-so-nearby) towns. The male and female divisions are clearly delineated, as they were in day-to-day life of Pennhurst. This decades-old split was soon to be turned upside down, as a new approach to serving individuals with intellectual disabilities swept over the facility. (Author's collection.)

ON THE COVER: In 1926, a group of "inmates" made wicker furniture in the basement of a Pennhurst residence. The finished items were sold to employees and the public. Many pieces of this elegant furniture were still in use among Pennhurst's offices and public spaces 60 years later when it closed. The image was published in a report of the board of trustees. (Author's collection.)

IMAGES
of America

PENNHURST STATE
SCHOOL AND HOSPITAL

J. Gregory Pirmann and the Pennhurst
Memorial & Preservation Alliance

ARCADIA
PUBLISHING

*This book is dedicated to the people of Pennhurst. Their lives
teach us that every person has much to contribute to society.*

CONTENTS

ACKNOWLEDGMENTS

I wish to thank my friends and colleagues on the board of the Pennhurst Memorial & Preservation Alliance (PM&PA) for their support and encouragement in this undertaking. I must especially thank Nathaniel Guest for bringing me back to the Pennhurst story at a very low point in my life. Thanks also to Bill Brunner, executive director of the Spring-Ford Historical Society, for sharing the group's resources and his personal experiences as an author with Arcadia Publishing. Thank you as well to the various contemporary photographers who allowed the use of their images of Pennhurst after the doors had closed. I would be remiss if I did not also acknowledge the late Harold Amster, Pennhurst's staff photographer for 30 years. Much of what happened at Pennhurst from the 1950s to the 1980s was captured by Amster. Tragically, the bulk of his photographic archives were left behind when Pennhurst closed, and they were lost or destroyed by the visitors who decided that vandalism was the best way to commemorate the lives of all those whom society sent to Pennhurst.

I also must acknowledge the more than 10,600 people sent by society to Pennhurst, a place designed to contain, control, and dehumanize them. Despite the odds, those individuals managed to find many different ways to hold on to their humanity, rise above their circumstances, and ultimately lead lives of quiet dignity in a world that tried to deny their worth each day. The people of Pennhurst taught me more than I could ever teach them. They taught me that every life is valuable, and every person, however we label them, has much to contribute to society.

Unless otherwise noted, all photographs come from the author's personal collection of Pennhurst-related paper ephemera.

INTRODUCTION

As America rapidly changed from an agrarian to an industrialized society in the 19th century, the social scientists, medical professionals, and educators of the time identified a new class of people who posed a new set of challenges, an unsolved set of problems. Beginning around 1850, America began to address the "problem of the feeble-minded" by creating a new kind of institution, one that would differ from the asylums that housed the poor, the "lunatics," the petty criminals, and all of the others who did not fit elsewhere. By the middle of the century, it had been decided that the "feeble-minded" belonged in places of their own. Thus were born what would become the state schools of the 19th and 20th centuries. Pennhurst was one of those new places, founded as an "institution for the care and maintenance of epileptics and idiotic persons."

The identification of the "feeble-minded" as a special class of people with special needs was originally a positive development, intended to help children for whom existing schools were insufficient in teaching the skills needed to fit into a changing society. Unfortunately, the idea of helping the "defective child" to learn was soon replaced with the belief that they needed to be isolated, first to protect them from those who would take advantage of them and then, more insidiously, to protect society from those who were seen as the cause of many problems of society. The so-called best minds of the late 19th century became convinced that poverty, crime, prostitution, and drunkenness were caused by "mental defect." Removing the "defectives" from society and preventing their procreation would certainly solve "the problem of the feeble-minded" for all time and, while doing so, would also cure the ills of society for which they were being blamed. Pennhurst was a product of the pseudoscience that asserted that people with intellectual disabilities needed to be shut away from the world for their own benefit and, more pointedly, for the benefit of the larger society. Pennhurst was designed to be a world apart, one that would function nearly independently and could be, if not forgotten entirely, ignored just as the people sent there were.

To understand Pennhurst, one must first understand the concept of dehumanization. No one made a conscious decision to build a place that would lead to decades of neglect and abuse for thousands of people. But it happened. Life in these large custodial institutions was harsh, with restrictions (and punishments) that were built into the day-to-day operations out of necessity. How could the good intentions of the best minds turn so horribly wrong? The answer is simple. Unfortunately, all societies identify people who are not like the majority. These distinctions can be based on race, skin color, religion, place of origin, and so forth. Once a group has been labeled, it becomes easier to allow bad things to happen to them, and it becomes easier to do bad things to them. American society is no different from the others that have dehumanized groups they distrust, dislike, and disdain. As people with intellectual disabilities were grouped together in the second half of the 19th century, they too were dehumanized, made less than us, made "not us." Places like Pennhurst were the brick-and-mortar realizations of this process of dehumanization.

Pennhurst's 80 years were characterized by many things. Chief among them were overcrowding, leading to the warehousing of vast numbers of people in buildings that were always in need of repair; chronic underfunding and understaffing; recurring scandals, the first beginning a mere four years after the first "patient" was admitted; and terrible treatment of the "patients" by some workers, usually balanced (but not excused) by the caring actions of the majority of employees. The history of Pennhurst is one of neglect by the very society that created it, punctuated by periodic anger over the conditions that were the inevitable by-product of that neglect. And after the anger subsided, little changed, and the facility slipped back out of our consciousness, waiting for a decade or two to pass until another scandal erupted.

In the mid-1960s, the bleak world of the large custodial institutions finally began to change as people realized that the science that had driven the facilities since their creation was wrong. In many ways, Pennhurst was a leader in making those changes—changes brought about by the realization that everyone had the potential to grow and learn. The institution was also embroiled in legal battles designed to guarantee the human and legal rights of all people. Those decisions brought about change that might not have occurred otherwise. These changes finally gave people with intellectual disabilities control over their lives and allowed them to reclaim their place in the world. Society finally came to realize that separate worlds like Pennhurst built more than a century ago were no longer needed, if they ever were.

From its very beginning, Pennhurst was the wrong answer to the wrong question. The question of how to solve "the problem of the feeble-minded" raised 150 years ago need never have been asked. The problem was caused by the mistaken attitudes of society, not by the actions of people with intellectual disabilities. Building Pennhurst and the hundreds of places like it was the wrong answer for a question that should not have been asked. Creating worlds apart for people we dehumanized—people we made an "other," made "not us"—was wrong.

Much of this book highlights the problems that plagued Pennhurst and the mistakes made by society when it was created and maintained for eight decades. Having said that, there is one other point that must be made: for the most part, the people who worked at Pennhurst were not the problem. On a day-to-day basis, they did what they believed was right, according to the prevailing ideas of each era. While some acted badly, most believed in what they were doing and truly cared about the people with whom they worked. The neglect inherent in the custodial model of care was not the fault of the overworked employees who stuck it out at Pennhurst; it was the fault of us all because we allowed a group of people to be rendered invisible, to be made different from us. Once they were seen as different, we accepted the fact that what happened to them did not matter because they were not us and we were not them.

The prevailing mythos about Pennhurst is that it was a horrible place where terrible people did terrible things. Sadly, that story line misses the point. Pennhurst was a place that never should have existed. Terrible things did happen there, but blaming them entirely on the people involved allows society to escape its own guilt. Society chose Pennhurst for people it feared, people it misunderstood, people it wished to forget. The question of what it would have taken for Pennhurst to work has often been asked. All the money, all the resources, all the good intentions would not have been enough to correct the basic mistake that Pennhurst represented. People with disabilities, intellectual and otherwise, do not need to live in a false world apart. They need what we all need—acceptance, friends, love, and community.

One

CREATING A
SEPARATE WORLD

An act of the Pennsylvania Legislature created Pennhurst State School and Hospital on May 15, 1903, as the "Eastern Pennsylvania State Institution for the Feeble-Minded and Epileptic." The legislation appropriated sufficient funds to erect a facility for not less than 500 persons and specified, "The buildings shall be in two groups, one for educational and industrial department and one for the custodial or asylum department." Section 10 of the enabling legislation passed in 1903 further detailed the institution as follows:

> That this institution shall be entirely and specifically devoted to the reception, detention, care and training of epileptics and of idiotic and feeble-minded persons of either sex . . . [and] shall provide separate classification of the numerous groups embraced under the terms "epileptics" and "idiotic" and "imbecile" or "feeble-minded." Cases afflicted with either epilepsy or paralysis shall have a due proportion of space and care in the custodial department. It is specifically determined that the process of an agricultural training shall be primarily considered in the educational department; and that the employment of the inmates in the care and raising of stock, and the cultivation of small fruits, vegetables, roots, et cetera, shall be made tributary, when possible, to the maintenance of the institution. All inmates shall be subject to such rules and regulations as the board of trustees may adopt.

The Eastern Pennsylvania Institution admitted its first client on November 23, 1908. With these words, the Pennsylvania Legislature began a story that would last more than 80 years as an operating institution and decades longer as an important part of history, more specifically the history of how America chose to serve and support individuals with intellectual disabilities. Pennhurst came to symbolize everything that was wrong with the custodial model of care and everything that was right about the change to community-based, individualized support. The sturdy buildings erected on a hill overlooking the Schuylkill River hid many terrible things for too many years.

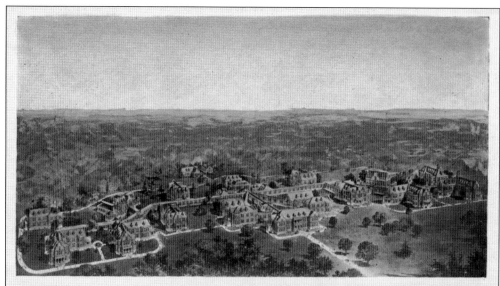

Frank Kline, Pub., Spring City, Pa.

16—Hospital for Feeble Minded and Epileptics now building at Spring City, Pa.

The artist's conception of the campus pictured above was never fully realized. Many of the buildings shown on what would have been a very crowded campus were never completed. It is likely that financial constraints were at least partially at fault for the decision to limit the number of major buildings on the lower campus to 18 rather than the 20-plus shown in the illustration. Building a separate campus for women, which would be located at a distance from the original campus, was probably also a factor in the change from the conceptual to the actual. The photograph below shows the administration building in the mid-1960s, as seen on an employee recruitment brochure. (Above, Spring-Ford Historical Society; below, author's collection.)

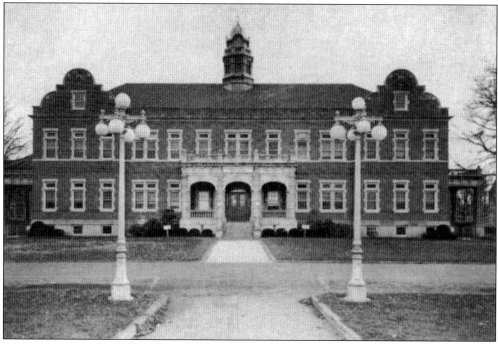

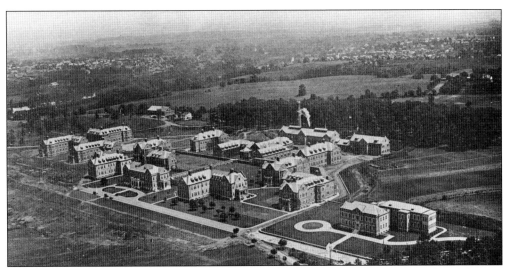

This view of the original campus was published in the biennial board report for 1921–1922. Within a decade, the female colony was created in the open area beyond the main campus. The original group of buildings became known as the male division. The creation of the two campuses finally allowed for segregation of the sexes, one of the major goals of the institution's board from the beginning.

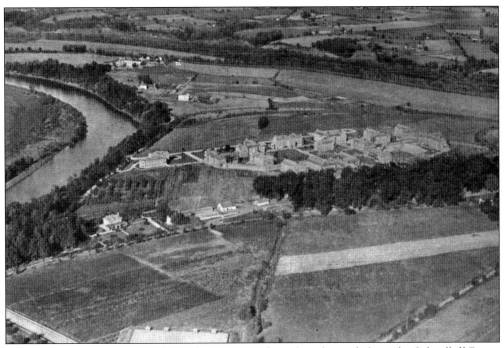

This view, dating from 1926, shows the extensive dairy farm located along the Schuylkill River. While not visible in the photograph, the Schuylkill Canal carried coal across the Pennhurst dairy farm, from northeastern Pennsylvania to Philadelphia and other markets, and a 19th-century lockkeeper's home was used as part of the dairy complex. The Reading Railroad also ran through the campus.

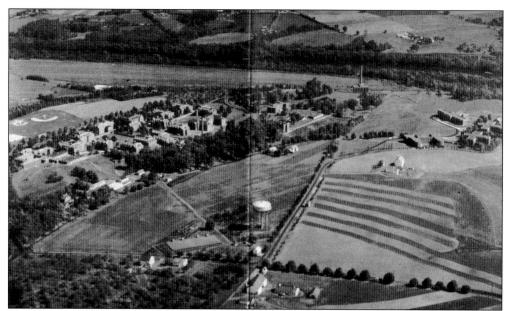

A 1960 photograph depicts the campus as it existed from the completion of the last two major buildings after World War II. In 1969, a large high-rise was erected adjacent to the water tower. This building was initiated as the first step in the creation of an entirely new Pennhurst, one that would have immortalized the mistakes of the past in bricks and mortar. Thankfully, the plan was scrapped.

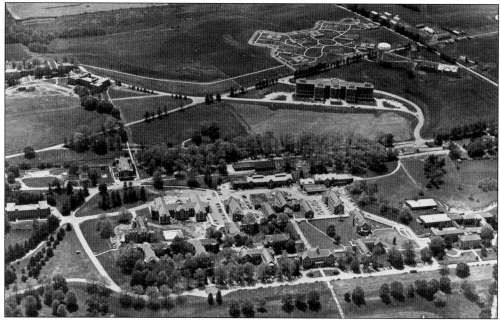

This final view captures the Pennhurst campus as it existed until the facility's closure in 1987. One of the buildings in the female colony (upper left) is now used as a National Guard armory. The other four are abandoned. Completed in 1971, the New Horizon Building (renamed Horizon Hall in 1979) is now a veterans home operated by the Pennsylvania Department of Military and Veterans Affairs. The original campus was sold to a real estate developer in 2008.

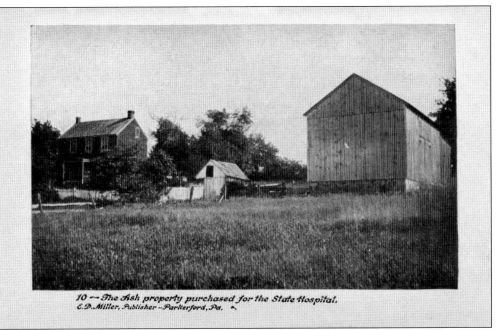

10 — The Ash property purchased for the State Hospital.
C.D. Miller, Publisher – Parkerford, Pa.

The decision to build a major institution in the area aroused public curiosity. Several publishers tried to meet the public's interest in the new facility by issuing postcards displaying the buildings as they were erected. Many of these unique postcards have been preserved by area historians and postcard collectors. In addition to the new institutional buildings rising from the farmlands of Chester County, one publisher also issued a series of cards containing views of the existing houses on the farms bought by the state. Many of these farmhouses remained in use until the 1970s, providing housing for employees and, in some cases, for individuals working on the farms. (Both, Spring-Ford Historical Society.)

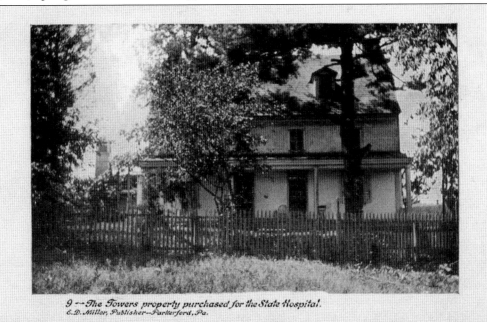

9 — The Towers property purchased for the State Hospital.
C.D. Miller, Publisher—Parkerford, Pa.

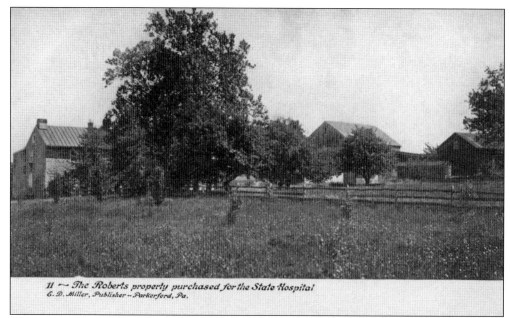

11 — The Roberts property purchased for the State Hospital
E. D. Miller, Publisher -- Parkerford, Pa.

These two additional postcards featuring farmhouses purchased as part of the new institution's construction demonstrate one of the problems that has plagued the field of intellectual disabilities since its very beginning. The facility to be constructed was never intended to function as a state hospital. State hospitals were (and still are) designed to treat individuals with mental illness. As clearly designated by the legislature, Pennhurst was designed to serve the "feeble-minded" and "epileptic." None of the people included in those groups necessarily have a mental illness. But the seeds of confusion had been planted even before Pennhurst opened, leading the superintendent to complain in 1912 that "the misunderstanding and confusion in regard to the class of cases to be cared for . . . still continues." That confusion and misunderstanding between the two groups continues in many people's minds today. (Both, Spring-Ford Historical Society.)

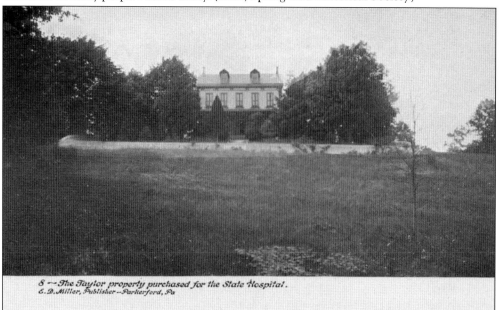

8 — The Taylor property purchased for the State Hospital.
E. D. Miller, Publisher -- Parkerford, Pa

14

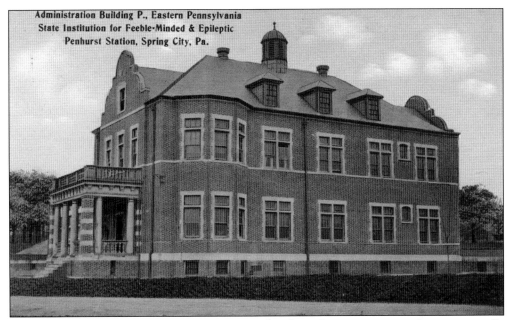

P Building was one of the first structures completed on the main campus. It was originally intended for use as professional offices but was instead pressed into service as the administration building when the facility opened. When the actual administration building finally opened in 1918, P Building became a dormitory housing the facility's teachers. It eventually became home to several professional departments and remained in use until Pennhurst closed in 1987. (Spring-Ford Historical Society.)

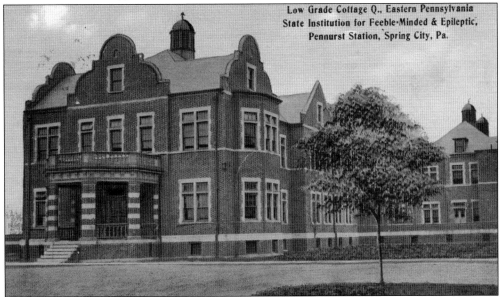

Q Building was one of the original 1908 buildings, in use until the institution closed. For many years, there were 150 people, 75 on each floor, living in what was one of the smallest residential buildings on campus. When modern standards were applied, the capacity was lowered to 16 people per floor, a fifth of the number of people who had lived there for more than 50 years. (Spring-Ford Historical Society.)

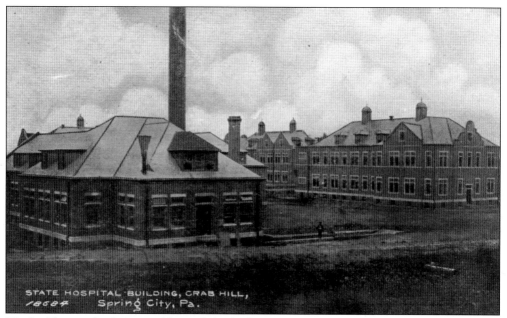

STATE HOSPITAL BUILDING, CRAB HILL,
Spring City, Pa.

The building in the foreground housed the facility's storeroom, laundry, and other maintenance operations. The chimney marks the location of the original power plant. The maintenance building is distinguished from the various residential buildings in the background by the lack of ventilation cupolas. (Spring-Ford Historical Society.)

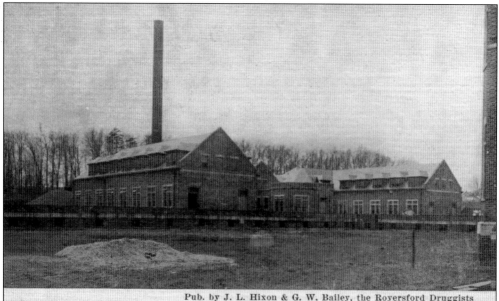

Pub. by J. L. Hixon & G. W. Bailey, the Royersford Druggists
DINING-ROOM BUILDING, EASTERN PA. STATE INSTITUTION FOR FEEBLE-MINDED AND EPILEPTIC, PENHURST STATION, SPRING CITY, PA.

This view shows the two main dining rooms on the original campus. The octagonal building in the center was the officers' dining room, where the physicians, nurses, and other professional staff took their meals. The smokestack in the rear was part of the original power plant. A new power plant designed to serve both the lower campus and the female colony was completed in 1950. (Spring-Ford Historical Society.)

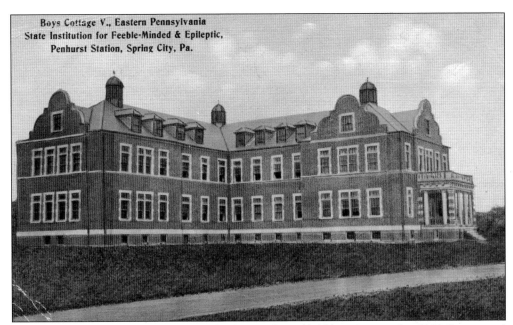

Like Q Building, V Building was one of the first residential buildings occupied in 1908. It remained in use until the late 1960s, when the combination of a decreasing population and the expense needed to maintain it led to its closure. V and U Buildings were essentially mirror images of one another. In 1955, the two buildings housed a total of 315 individuals between them. (Spring-Ford Historical Society.)

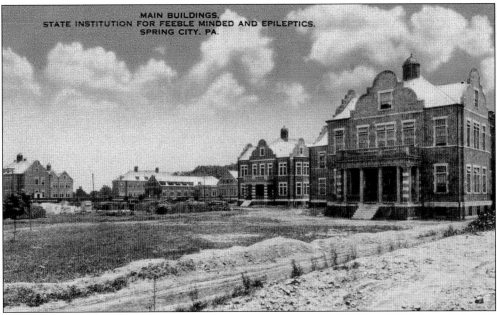

This card captures a wide view of the lower campus as construction moved forward in the years immediately after the 1908 opening of the institution. From left to right are P Building (Philadelphia Building), Q Building (Quaker Hall), R Building (which housed the school and was later renamed Rockwell Hall), the dining halls, I Building (later renamed Industry Hall), and K Building (demolished in the 1970s). (Spring-Ford Historical Society.)

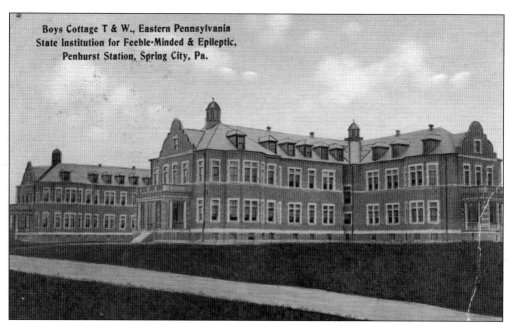

Boys Cottage T & W., Eastern Pennsylvania State Institution for Feeble-Minded & Epileptic, Penhurst Station, Spring City, Pa.

The building in the rear was misidentified on this card. It is actually U Building. (There was no W Building.) It was one of the first residential buildings taken out of service as Pennhurst's population shrank in the late 1960s. The commonwealth planned to demolish U and V Buildings in the 1970s but decided against it because of the cost and difficulties encountered in the demolition of K Building. (Spring-Ford Historical Society.)

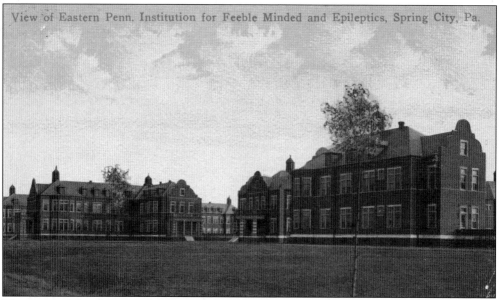

View of Eastern Penn. Institution for Feeble Minded and Epileptics, Spring City, Pa.

This is an undated panoramic view of the original campus. The cookie-cutter nature of the architecture of the residential buildings makes it difficult to identify these structures by name. Philip H. Johnson, the chief architect of the city of Philadelphia, designed the original Pennhurst buildings. He also designed buildings for the Philadelphia State Hospital at Byberry and the Philadelphia General Hospital, as well as Philadelphia's city hall annex and convention hall. (Spring-Ford Historical Society.)

No. 24. CHILDREN'S COTTAGES, State Institution, Spring City, Pa. FRANK KLINE, Pub., Spring City, Pa.

Above are L and K Buildings, pictured near the end of construction. The cupolas were designed to provide for the ventilation of hot air from the interior of the residential buildings. They were removed in the 1960s because they leaked constantly and became impossible to maintain. Only the main cupola on the administration building below remains. It was deemed historic, and its demolition was not allowed. The eyebrow windows flanking the cupola were removed, however. A significant portion of the copper sheathing covering the administration building's cupola was stolen by scrappers in 2008. In an attempt to maintain the building's appearance, the current owner has resealed the open areas with plywood. The building adjacent to A Building is M Building (Mayflower Hall). (Both, Spring-Ford Historical Society.)

PENN HURST STATE SCHOOL
PENN HURST PA.

State Hospital Buildings between Parker Ford and Spring City, Pa.

The postcard above includes a temporary building erected during the facility's construction. It might have been used as housing for the builders. In the foreground is R Building, which served as the facility's school. Q Building sits across the walkway from R Building. The image below demonstrates that even the superintendent's residence was considered worthy of a postcard. This large home was built specifically for the superintendent and his family, and it is clearly out of character with the farmhouses that dotted the newly assembled campus. The home remained in use until the early 1980s and was included as part of the campus repurposed as a veterans home in 1983. It has recently been slated for demolition despite ongoing efforts to preserve it. (Both, Spring-Ford Historical Society.)

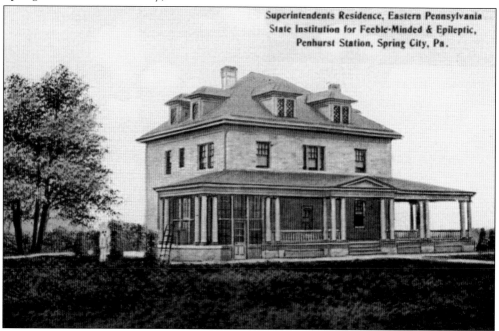

Superintendents Residence, Eastern Pennsylvania State Institution for Feeble-Minded & Epileptic, Penhurst Station, Spring City, Pa.

Two

BUILDING THE INSTITUTION

The construction of Pennhurst was an almost continual process for 25 years, beginning when the legislature authorized the institution in 1903 until the end of the 1920s (and the start of the Great Depression.) The 1924–1926 board report contains a summary of the early history of the facility: "The first buildings opened for patient use were buildings T and Q. By May 31, 1910, ten buildings were in use and the eleventh was under roof. The original plan of the institution called for twenty-three buildings." The act creating Pennhurst specified the following:

> Buildings shall be in two groups, one for the educational and industrial department, and one for the custodial or asylum department, with such other subdivisions as will best classify and separate the many diverse forms of the infirmity to be treated; and shall embrace one or more school-houses, a gymnasium and drill-hall, a work shop and an isolating hospital, all on such scale as will create an institution to accommodate not less than five hundred patients, planned and located for easy and natural additions, as population demands.

The aerial views of the campus show that the legislative requirement of two groups was ignored. It was not until ground was broken for the female colony in the 1920s that two distinct groups of buildings existed, with the new group located nearly a mile from the original campus.

Beginning as early as 1912, the board reports contain numerous complaints about the need for funds to enact changes and repairs to buildings that were less than a decade old. The 1912 report included a request for $25,000 for general repairs in buildings that had been in use for only four years. Included on the list of needed work was "painting the buildings, replacing unsanitary closets and unsafe bath rooms, rebuilding stairways [and] adding such ventilating apparatus as is absolutely necessary." Subsequent reports made similar requests for upgrades and repairs. The lack of funds for repairs and improvements would be a constant curse at Pennhurst, most vividly displayed in the exposés of the 1960s and 1970s.

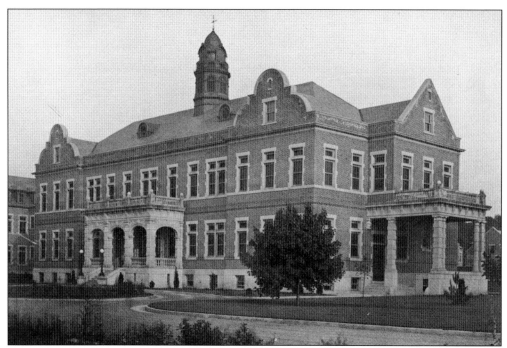

The administration building was completed in 1918, and it served as the "front door" of the institution. For many visitors, it was the only part of the campus they ever saw. The offices of the superintendent, medical director, steward, and other key staff were located here. Constructed during a time of relative austerity, it lacked much of the more ornate decor usually associated with the main buildings of other public institutions.

In their 1916 report, the board noted, "Building has constantly been going on . . . [and] has prevented any systematic beautifying of the grounds. This . . . should be taken up as soon as possible . . . [with] ornamental trees and shrubbery set out." This 1922 photograph clearly demonstrates that the desired landscaping was successfully accomplished. The fact that it was completed using the uncompensated labor of the "inmates" was never mentioned.

An unidentified young girl spent the summer of 1916 visiting Pennhurst, presumably living with the family of the superintendent. During that summer vacation, she took a number of photographs of the institution being erected around her. Those images were later donated to the Spring-Ford Historical Society. They are reproduced here for the first time with the gracious permission of the historical society. The two shots on this page show buildings nearing completion, with construction materials still stacked nearby. (Both, Spring-Ford Historical Society.)

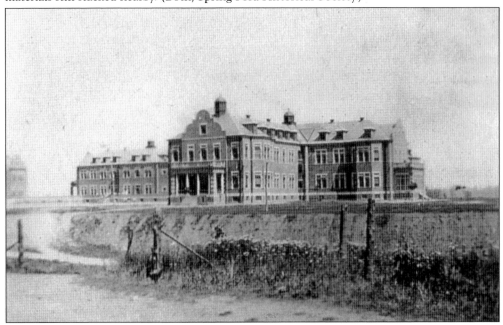

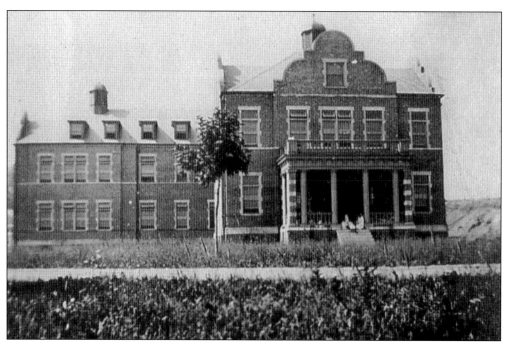

The 1916 snapshot above shows one of the newly completed buildings with "inmates" sitting on the porch. A lone tree stands amid the untended grass surrounding the building, in stark contrast to the manicured grounds pictured in 1922 (see page 22). The shot at left says a great deal about the status of the superintendent and the ornate home that had been built for him. When this photograph was taken, concerns over the issues of overcrowding and underfunding were already a significant factor impacting the lives of the people sent to Pennhurst, people whose homes did not look at all like this mansion. (Both, Spring-Ford Historical Society.)

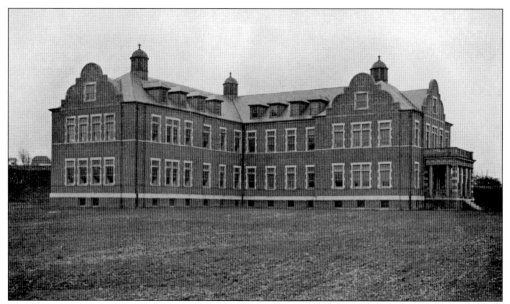

Overcrowding was a problem as soon as Pennhurst opened. K Building is pictured here in 1912. The board reported that it "was handed over to us June 1, 1911, . . . [and] received its first inmates October 10, 1911, thus relieving the crowded conditions of the other buildings." K Building was torn down in the late 1970s, giving it the distinction of being the only building on campus that was demolished.

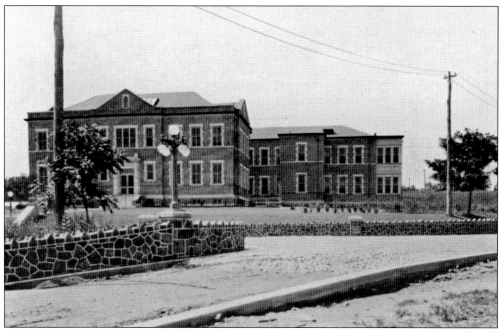

In 1922, the chief physician reported, "In December 1921 our new hospital building was opened, a most valuable addition to our institution plan. Your board is to be congratulated upon the achievement of such excellent provision for caring for the sick among our children and employees." The hospital remained in use as a full-service, accredited facility until the late 1960s. The building in the rear housed the hospital wards.

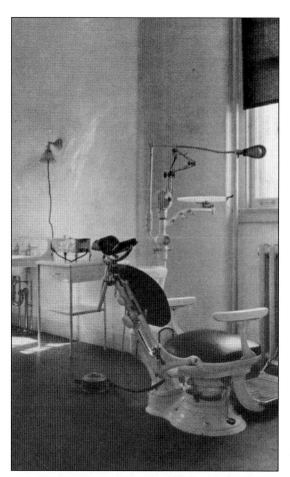

According to the 1922 board report, "The dental rooms have been furnished with the most modern appliances, where our children can be given the dental attention which is so greatly needed in so large a number of them, and so necessary to their general health and well-being . . . The operating and sterilizing rooms have been fitted up with the most approved equipment and the laboratories for pathological and psychological research and X-ray work are a most valuable acquisition to an institution such as ours."

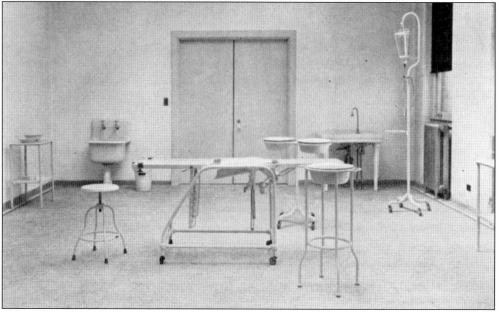

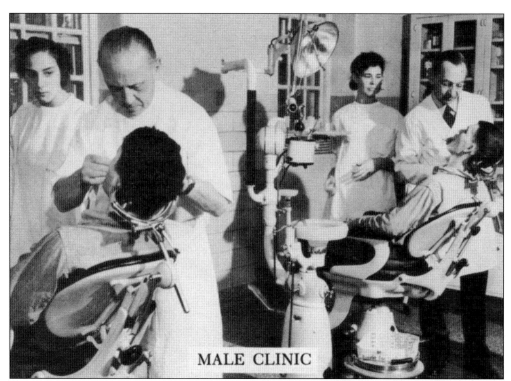

MALE CLINIC

These photographs of dental services were published in 1954, three decades after the opening of the hospital and the original dental clinic. By that time, newer equipment had been added, and a separate dental suite for women had been established in the female colony. Two dentists, one dental intern, and one oral hygienist were employed to meet the needs of the 3,500-plus individuals living in the facility. The efforts of the paid staff were supplemented by "four trained female patients" who acted as dental assistants.

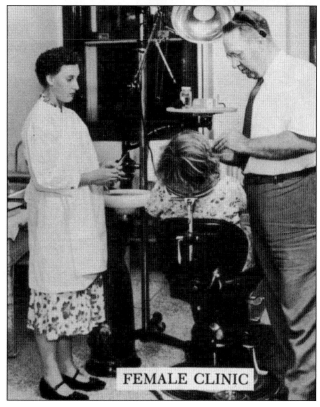

FEMALE CLINIC

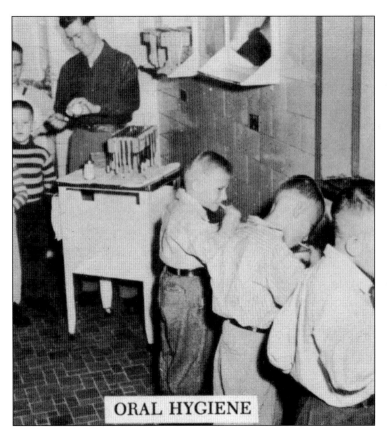

ORAL HYGIENE

This photograph of children brushing their teeth was also included in the 1954 publication. Not understood at the time was that hanging the children's toothbrushes together was an invitation to the spread of infectious disease, especially hepatitis, which was endemic in institutions like Pennhurst. It is also unclear from the image whether each child had his or her own toothbrush or if they just used whatever was available. The latter is more likely.

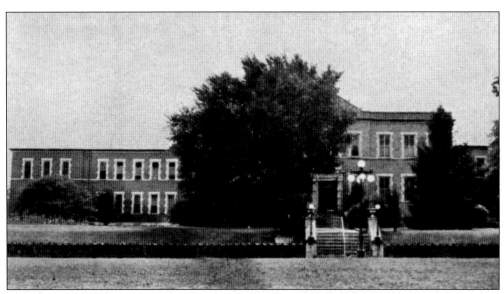

This photograph shows a front view of the hospital in the mid-1940s. The dental suite and pharmacy were located on the first floor, with the operating room on the second floor. The hospital wards were located in the building at left, connected to the main hospital by an elevated walkway leading from the rear of the hospital over a driveway. This building was later named Whitman Hall.

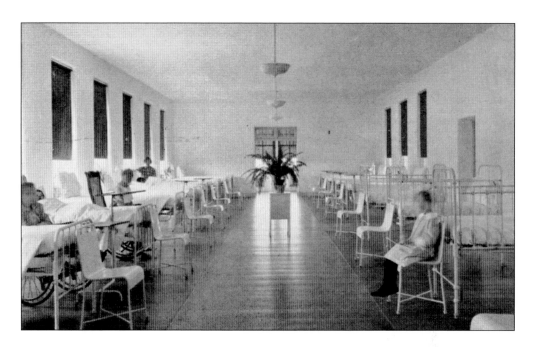

Quoting further from the 1922 chief physician's report, "This building is most modern in every appointment. The wards are large, airy and well-lighted. The diet kitchens in each ward make it possible to prepare and serve diets to the sick in the most acceptable manner possible." The report says much about the mind-set of Pennhurst's administration and of society at large in regard to individuals with developmental disabilities. Everyone in the facility was referred to as a child, even though many were adults. Denying people the recognition of their actual age and status as adults is an insidious form of dehumanization. The photograph above is captioned "girls' ward," and below is the "boys' ward."

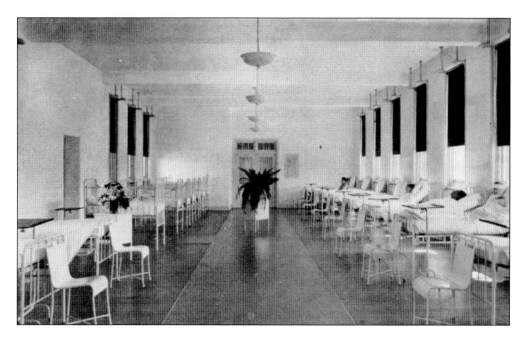

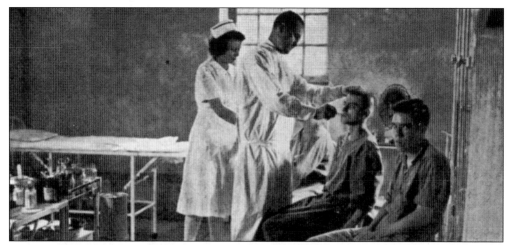

This 1940s photograph shows the male clinic, located in the basement of the hospital. Individuals with an acute illness were taken to the clinic to be seen by a nurse or physician. Medical care was not generally available in the residential buildings because there were too few personnel available to travel across campus to patients.

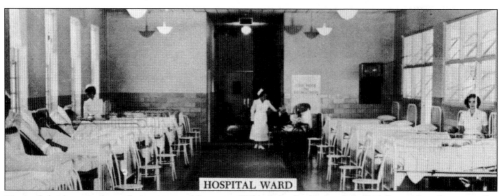

One of the hospital wards is pictured here in 1954. It looks little changed from the photographs published in the board reports 30 years earlier. One noticeable difference is the narrow space between beds, reflecting the difference between the 1,200 people in residence in 1922 and the 3,500 individuals who were living at Pennhurst in 1954.

This 1954 photograph shows the separate wards designed for the treatment of tuberculosis. The TB hospital was constructed adjacent to the original hospital in the early 1950s. Advances in the treatment of tuberculosis quickly made the separate facility unnecessary, and it was repurposed as a residential area for visually impaired individuals as part of the 1966 Hospital Improvement Grant program. The need for a separate tuberculosis hospital was first mentioned in 1917, when the chief physician noted, "Feeble-minded and epileptic individuals are especially liable to this disease . . . The care of a case of tuberculosis in our crowded wards is not in accord with modern ideas." The first part of this statement was factually inaccurate. It was the conditions in which people were forced to live that made them "liable" to TB and other infectious diseases.

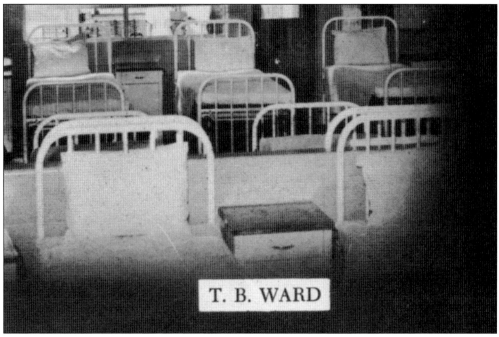

T. B. WARD

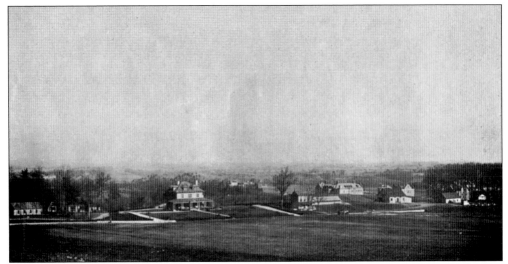

The 1918 board report included this panoramic view of the growing institution. The newly finished superintendent's residence dominates the scene, with an older farmhouse located next door. Greenhouses and garages complete the row of buildings. One of the newly completed residential buildings can be seen in the background.

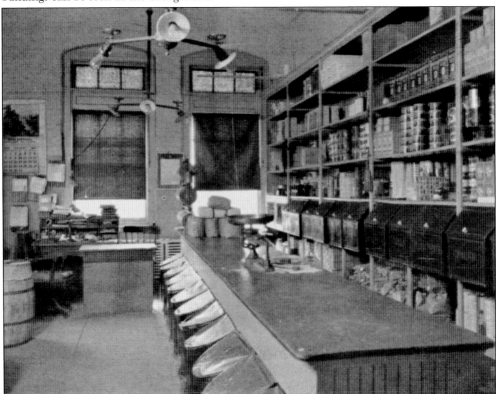

Even though the majority of food came from the facility's farm, this 1922 photograph reveals that some items were purchased commercially. In his report that year, the superintendent noted that one pressing need in the future was a "building for storeroom purposes, as our goods are scattered in eight different rooms, five of which are basement rooms."

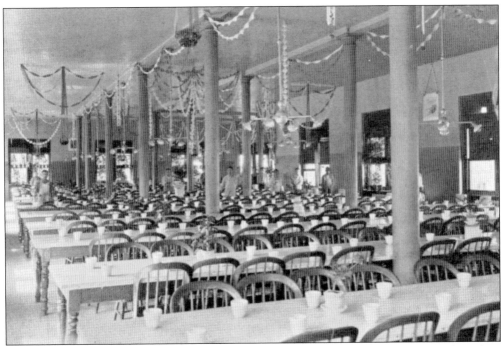

Decorated for a holiday meal, the "boys' dining room" is pictured here in 1922. Based on their attire, it seems likely that the individuals standing in the background are "working patients," possibly just arrived from the farm.

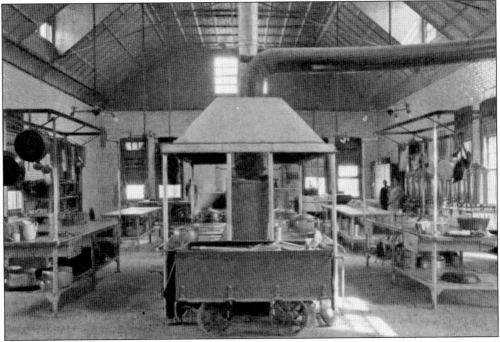

This is the main kitchen, pictured here in 1922. Meals for all the 1,200 "inmates" of the facility were prepared here, along with those for the employees, many of whom were required to live on campus. The kitchen was located between the gender-specific dining rooms in F Hall and N Hall.

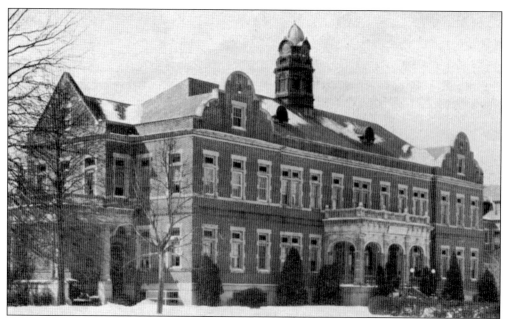

In 1916, the board of trustees proudly reported that a "commodious and convenient administration building is rapidly nearing completion, which will relieve the present crowded conditions of quarters for offices, etc. The second floor of this building will be used, until other accommodations can be secured, as an auditorium and assembly room and for indoor drills."

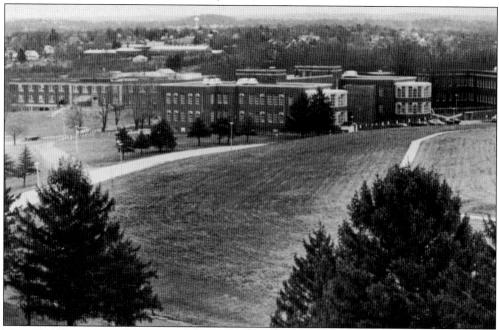

This panoramic view of the female colony/upper campus was taken from the water tower. The closest building is Female Building No. 3 (later renamed Keystone Hall), the only campus building erected during the Great Depression. Behind it on the left is Female Building No. 4 (Capitol Hall), constructed after World War II. The two original "female buildings" are seen to the right, behind Keystone Hall. (Spring-Ford Historical Society.)

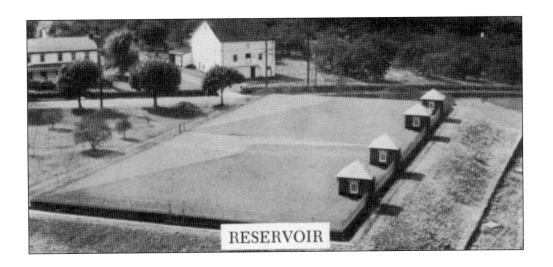

RESERVOIR

Further proof that Pennhurst was a world apart are these photographs of the reservoir (which was under a roof and supplemented by a water tower) and the sewage disposal plant. In 1954, the reservoir was filled by "seven deep water wells, [which] produce 500,00 gallons of water daily . . . pumped . . . from depths down to 900 feet." The disposal plant treated 350,000 gallons of sewage daily and was transferred to local control when Pennhurst closed. The reservoir is slated for demolition.

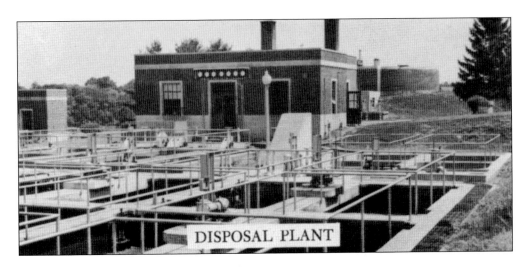

DISPOSAL PLANT

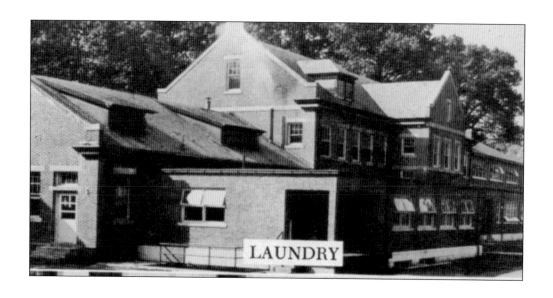

Contributing to the daily water and sewage usage was what was described as the "most modern laundry in Pennsylvania." The laundry processed 10 tons of linen and clothing each day. Eight automatic washers completed a 325-pound wash every 56 minutes. In 1954, the work of the laundry was carried out by six paid employees and 82 unpaid "working patients."

For the first 50 years of its existence, many of Pennhurst's employees were required to live on campus. In the early years, the lack of suitable housing was often cited as one of the reasons why it was hard to hire and keep staff. Many employees lived on the third floors of residential buildings, until employee quarters were constructed. This building was eventually used as housing for residents.

EMPLOYES' QUARTERS

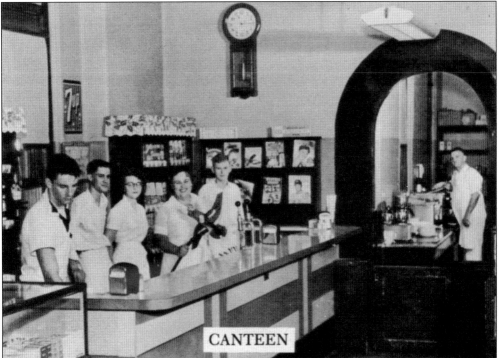

CANTEEN

Just like all small towns, Pennhurst had its own corner store and sandwich shop. One of the highest-status jobs for a "working patient" was serving as a runner for a building or office. The runner was sent to the canteen for coffee, sandwiches, and anything else that the employees wanted. Usually, the runner was rewarded with a small tip, even though tipping a "working patient" was explicitly prohibited.

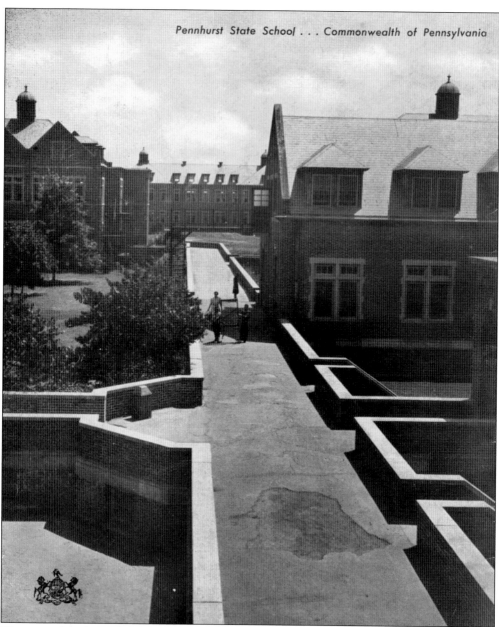

This view of the lower campus was featured on the back cover of an information booklet produced in-house in the mid-1940s. The photograph was taken from the F Building fire escape, looking toward the dining room. Q Building is on the left, with V Building in the background. The brick walls lining the walkways were eventually replaced with metal handrails when their maintenance became too expensive.

Three

MAKING IT WORK

When the legislature authorized the creation of Pennhurst in 1903, they included very specific language about who was to be admitted. They also stated, "The employment of the inmates in the care and raising of stock, and the cultivation of small fruits, vegetables, roots, et cetera, shall be made tributary, when possible, to the maintenance of the institution."

With this statement, the legislature established the manner in which Pennhurst would be operated until peonage was outlawed by the courts nearly 70 years later. Peonage was brought to an end when the Pennsylvania Legislature formally outlawed it in 1973 as the result of a lawsuit. The federal government soon followed. The employment of "inmates" not only contributed to the maintenance of the institution, but it also made the very existence of the facility possible. If not for the unpaid labor of the "inmates," the cost to operate places like Pennhurst would have been significantly higher, probably so high that society would have hesitated to keep the facility open. So the use of unpaid labor became a self-fulfilling prophecy: Pennhurst could not exist if all the work needed to keep it going had to be done by paid employees. And Pennhurst could not continue to exist if the training that was the supposed purpose of the "inmates' work" led to their exit from the facility. There was work to be done. And that work expanded as the facility expanded, so more and more unpaid workers were kept at Pennhurst despite being fully trained in whatever skills they needed to maintain the facility.

Agriculture, while clearly the most public aspect of the labor performed by the people living at Pennhurst, was not the only work they were required to perform. "Work boys" and "work girls" were found in every part of the facility, from providing care for the individuals in the custodial department to the laundry, kitchen, housekeeping, and maintenance facilities. The photographs on the following pages clearly demonstrate how pervasive the "employment of the inmates" was made "tributary to the maintenance of the institution."

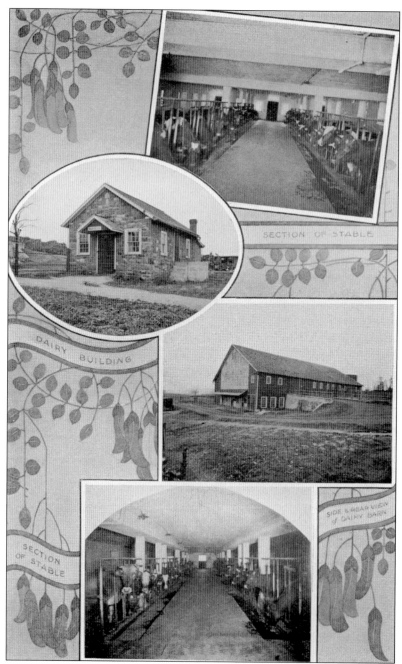

Farming the land was critical to the operation of Pennhurst, both to grow the food needed by the "inmates" and to turn a profit. In 1916, the board noted, "At the time of our last report the Institution occupied 490 acres of land owned by the State and another 250 acres on the opposite side of the Schuylkill River under lease. All of this land not occupied by buildings has been farmed up to its full capacity." As the institution grew, so did the farm. By 1954, the facility consisted of more than 1,400 acres and included not only field crops but also peach and cherry orchards, as well as "several acres of grape vineyards and raspberry patches." This photo collage was included in the 1912 board report.

VIEW LOOKING NORTH *from* INSTITUTION BUILDINGS
ONE OF OUR FARMS IN THE DISTANCE

SECTION *of* TRUCKING GROUND

CHESTNUT GROVE (ATTACKED BY BLIGHT)

The 1916 report added, "A large part of the vegetable gardens, truck and fruit used at the Institution has been raised on the premises, the major portion of the labor being done by the male inmates." The fact that their labor was coerced and uncompensated was never mentioned.

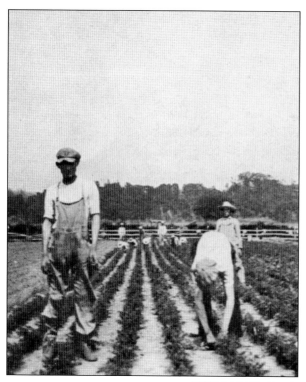

As noted in the 1922 board report, "In the agricultural line we aim to bring our boys in touch with farm activities just as soon as they are able enough. Even the small, high-grade boys spend part of the day in the garden, where they are taught to cover seed and to distinguish between weeds and young garden plants. They are taught how to hoe and care for the growing vegetables, also how to harvest the crop when matured." The photograph at left is captioned "weeding," and the one below is titled "picking peas."

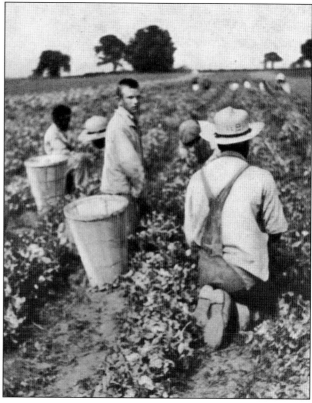

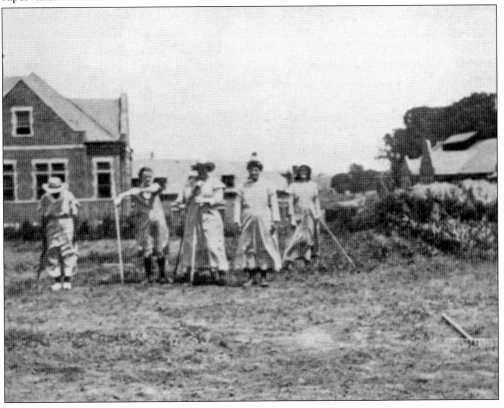

The "girls' garden" was located behind the residential buildings in the area where the hospital was eventually constructed. It was not considered a formal part of the farm program, although the production there was just as vital as that on the larger farm. The 1918 board report noted, "A tract of land has been set aside for the children's garden, one part of it for the boys and a part for the girls. The work in the girls' garden has been under the direct supervision of our Chief Nurse."

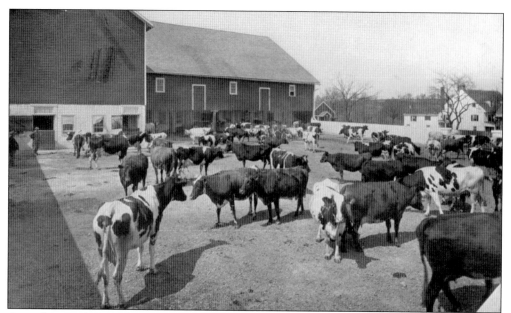

According to the 1916 board report, "The cattle herds, consisting of milk and beef cattle, have been added to by the acquisition of a Poll-Angus herd of pure strain . . . In the judgment of the Board, the beef herd of cattle is too large to be maintained with economical results and it has been considered wise to dispose of forty-three head at public auction."

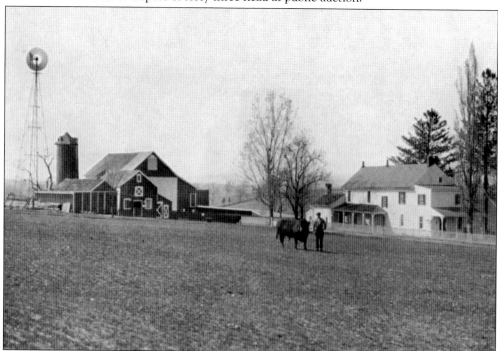

This 1918 photograph is captioned "beef fattening farm and buildings." Income reported from the farm that year included $450 for calves sold; $2,218 for 11,090 pounds of dressed beef sold at 20¢ per pound; $35.20 for 160 pounds of veal sold at 22¢ per pound; $360.18 for hides and tallow; and, last but not least, $3,511 for nearly 1,200 tons of manure.

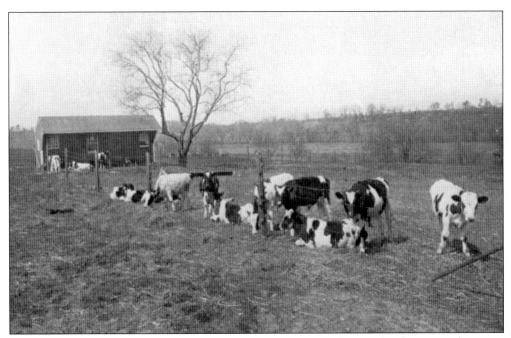

Another 1918 photograph is captioned "pure bred Holstein calves at the dairy." Total income from the dairy that year was $67,054.43, of which $8,124.66 was profit above expenses. At a cost of 7¢ per quart, 396,727 quarts of milk were sold. Adjusting for inflation, 1918's $8,000 profit translates to more than $125,000 today.

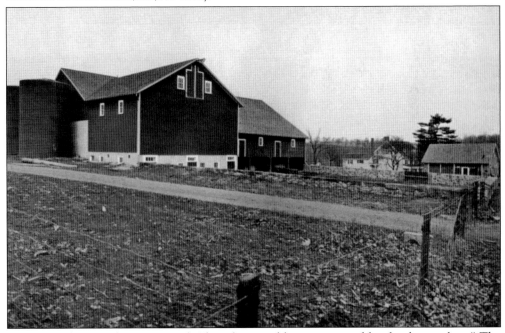

This 1912 photograph is captioned "dairy barn and house occupied by the dairy colony." The dairy house was originally built in the 1800s as an inn for workers on the Schuylkill Canal. The canal crossed the property, but by the time Pennhurst opened, business on the canal had decreased dramatically. The dairy house was used as a residence until the 1970s.

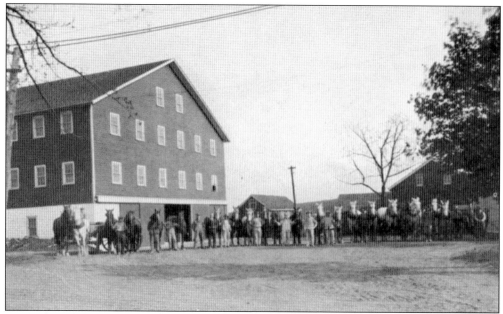

"A large number of the elder boys drive teams, help with the work at the dairy, piggery and poultry plants," according to the 1922 report. The institutional farm reported a profit of more than $40,000 for the 1920–1921 period, a profit made possible by the fact that the bulk of the labor on the farm was provided without compensation by the "patients."

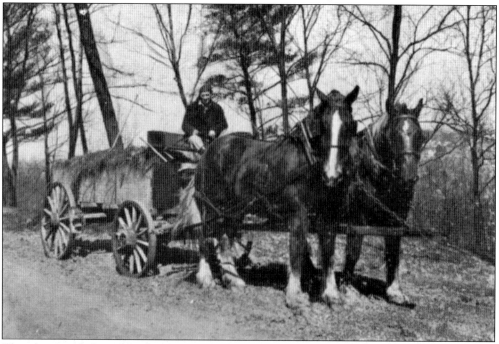

This photograph from the 1940s is captioned "patient driving a team, hauling a load of hay." The caption crystallizes much of what was wrong about the custodial model of care. This man was not ill (if he were, he would not have been working), and if he could be entrusted with this job, he was not in need of confinement.

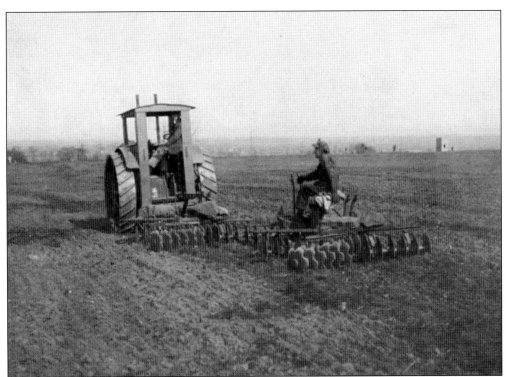

These images are the only photographic evidence of mechanization on the farm. With so much free labor available, modern farm equipment might not have been considered necessary. The photograph above is from the 1918 board report. It is titled "tractor and disks preparing an alfalfa field." Nearly 120 tons of alfalfa were harvested that year, valued at $25 per ton. The 1940s image below is captioned "a working patient operating the corn harvester in our corn patch."

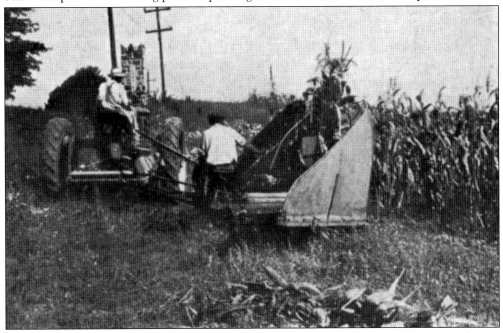

Pictured here is another view of the piggery in 1918. A total of 68,318 pounds of pork were sold that year, and the piggery listed a total profit of $7,730.17. Looking back over the 100 years since these board reports were published, it is telling how much information about the farming operation was included. Truly, the employment of the "inmates" was successfully being used for the maintenance of the institution.

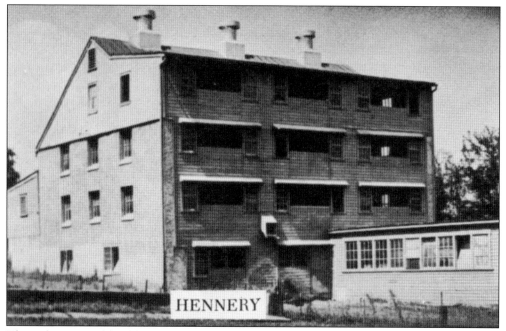

The informational booklet published in 1954 included multiple photographs of the farming operation, bringing it up to date from the board reports of the 1910s and 1920s. Pictured here is the four-story hennery. More than 15,000 pounds of meat and nearly 348,000 eggs (29,000 dozen) came out of the building that year.

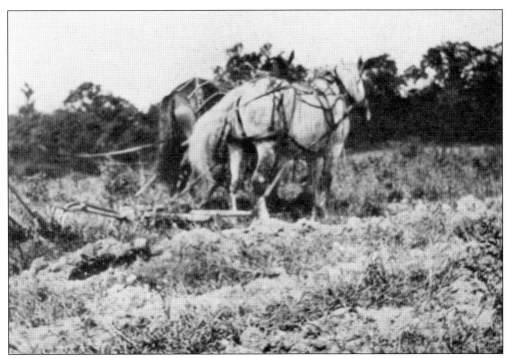

Stoop labor was the rule of the day when these photographs were taken in 1918. In the early years, there was little mechanization on the farm beyond the use of horse teams. Although it was 1918, these scenes would look familiar to a 19th-century farmer anywhere in the country. The two images were captioned "plowing out and picking potatoes." More than 5,000 bushels of potatoes were plowed and harvested by the "inmates" that year.

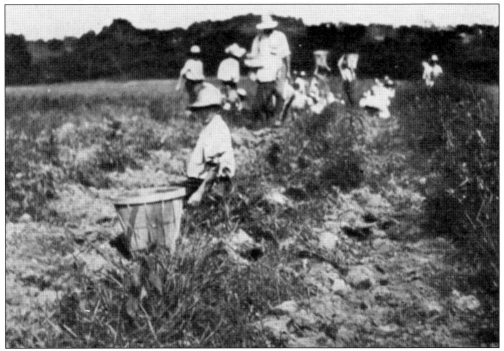

The photograph at left is captioned "picking stones." In the 1922 board report, the farm manager noted, "The lower grade boys are taught how to pull weeds along the road-sides and to gather stones in the gardens and fields." The caption for the photograph below is "loading hay." Both images were included in the 1918 board report.

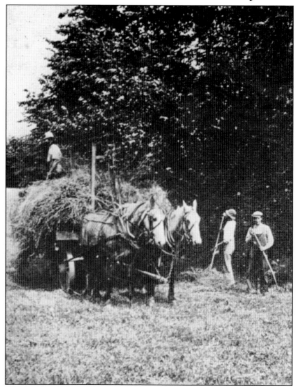

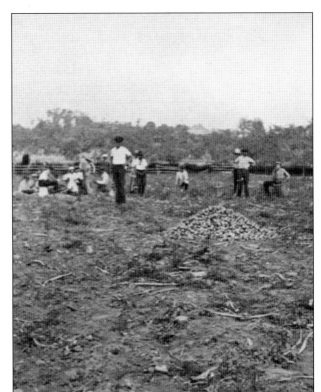

These photographs were published in the 1918 board report with the single caption "harvesting onions." The report also included the notation that 380 bunches of green onions, valued at 4¢ a bunch, were produced that year, along with 1,596 baskets of winter onions, valued at 90¢ per basket.

Even though Pennhurst was largely self-sufficient, some supplies did come from outside the facility. At the legislature's direction, the campus was "accessible, by railroad facilities, to the counties of Eastern Pennsylvania." This accessibility was enhanced by a spur that ran directly to the campus. The tracks were never removed, and they would periodically resurface through the asphalt of the parking lots that replaced them.

FARM REPORT

For Two Years from June 1, 1924 to May 31, 1926.

	Costs for 2 Years	Earnings for 2 Years	Net Earnings 2 Years
Farm	$47,598.84	$69,225.63	$21,626.79
Truck Garden	13,686.22	18,672.39	4,986.17
Dairy	65,167.58	86,279.30	21,111.72
Piggery	8,696.86	10,307.28	1,610.42
Hennery	8,034.53	9,286.40	1,251.87
	$143,184.03	$193,771.00	$50,586.97

SUMMARY

Gross Earnings for period of Two Years,	$193,771.00
Costs for period of Two Years,	143,184.03
Net Earnings for period,	$ 50,586.97

30

In this chart, the board proudly reported a profit of more than $50,000 from the farming operation for the two-year period ending in May 1926. Adjusting for inflation, the $50,000 in earnings realized in 1926 would be equivalent to more than $650,000 today.

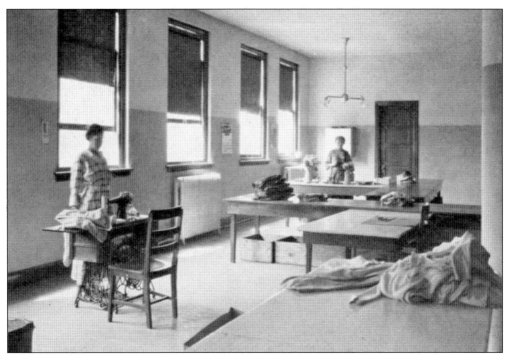

The farm was not the only part of the institution that was totally dependent on the uncompensated labor of the "inmates" to operate on a day-to-day basis. "Patient" labor fed those who could not feed themselves, cleaned and repaired their clothing, and did virtually everything else needed. The 1922 board report, from which these photographs are taken, included a summary of work done in the sewing room over the previous year: 2,228 items were made from discarded materials; 18,189 pieces were made from new material; 199,225 pieces were mended; 47,741 pieces were taped; and 103,004 pieces were marked. The total number of pieces handled was 370,378.

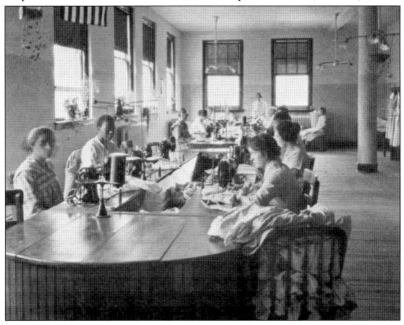

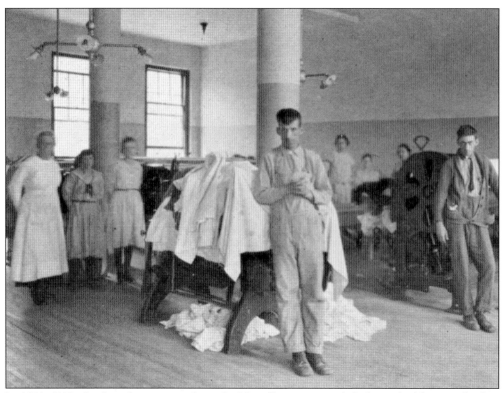

In 1921–1922, the laundry processed nearly 1.7 million pieces of clothing, bedding, and other goods. This mountain of work was completed by four paid employees and 40 "patients." The photograph above shows some of these unpaid "working patients" in the mangle room, and below is the washroom. These photographs were included in the 1922 board report.

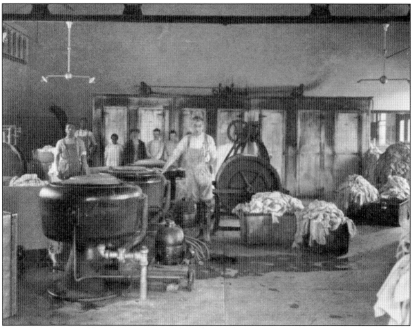

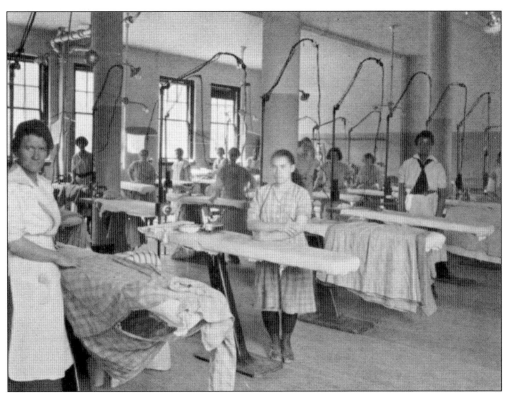

These photographs of "patient workers" in the laundry were also taken from the 1922 board report. They show the ironing room (above) and the assorting room (below). In their reports, the board never discusses the labor requirements placed on the "inmates" who were deemed capable of working. How many hours did they work each day? What happened if they refused to work? Before peonage was outlawed in 1973, "work boys and girls" put in 40-hour weeks and faced the loss of privileges if they refused to work. It is likely that conditions were no different in the 1920s, except that the number of hours worked per week was probably much higher.

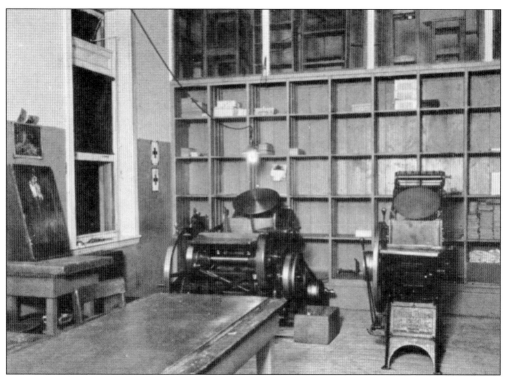

The 1916 board report noted, "Our printing department is one which has been of much service to the Institution. While the plant is small and while we are handicapped by not having a larger press, we are able to do practically all of the printing for the Institution . . . This department is most beneficial. Here the brighter boys are employed, and do quite satisfactory work. Besides having an educational value, it is a financial saving to the institution." The image above is from the 1922 report, while the one below is from 1918.

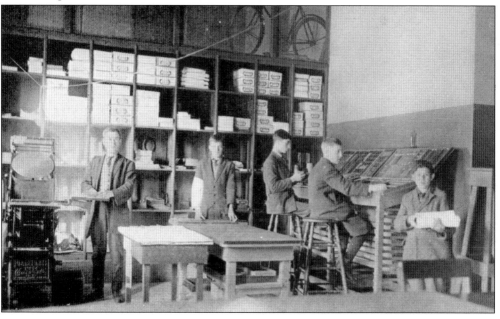

Printing remained an important activity until Pennhurst closed (albeit without "patient workers"). This image is taken from a 1954 information booklet that was produced completely in-house. The press in the photograph may be the same one seen in the earlier images. In 1954, the print shop was part of the occupational therapy department, along with the shoe shop and the tailor shop.

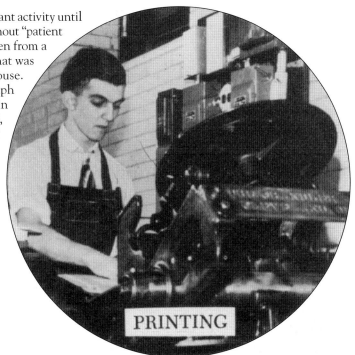

PRINTING

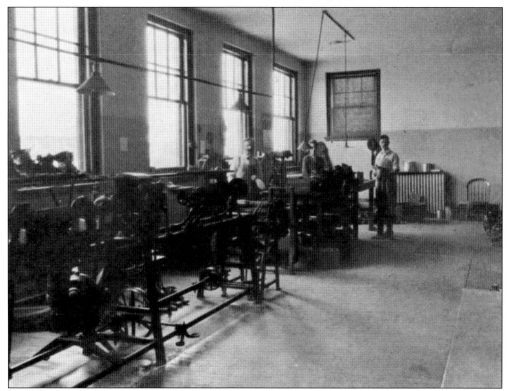

This is the shoe repair shop in 1922. The total amount of work done is not included in the board report, but the equipment certainly makes it seem as though this was a high-volume operation.

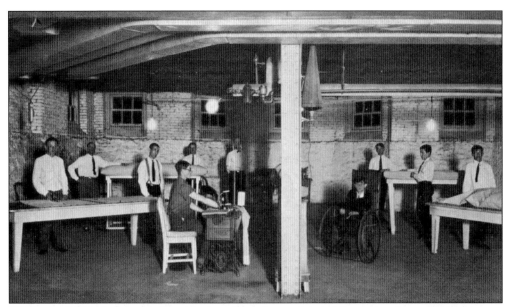

While this 1926 photograph from the board report was labeled "vocational training—mattress making," it seems obvious that many of the trainees are adults, and the work undertaken was not so much to provide marketable skills as to provide a product needed at the institution. The mattress shop was located in the basement of V Building. According to the board, seven "boys" were engaged in mattress work.

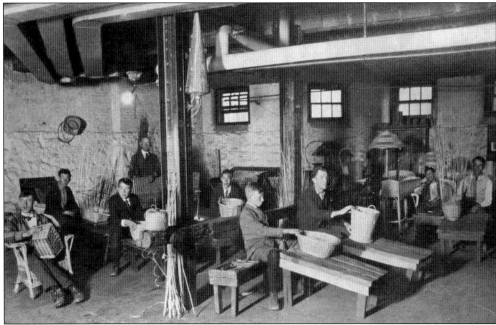

Another basement, another training opportunity that, rather than producing skills that could be translated into a future outside Pennhurst, was producing goods that would be offered for sale to visitors and family members, with the proceeds going to the children's entertainment fund. According to the 1926 board report from which this photograph was taken, a total of 513 willow and 327 reed and raffia articles were completed in 1925–1926.

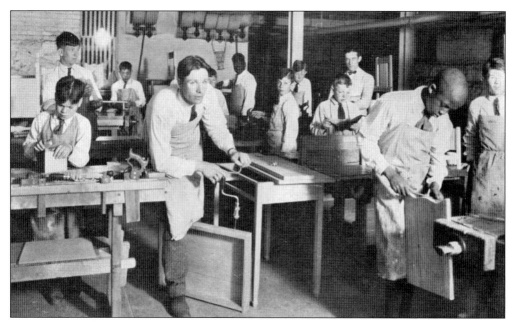

It is presumed that the gentleman with the bow tie is the instructor of this 1926 woodworking shop and the workers are "patients." As in other photographs, it is striking that these boys would not seem out of place (except for their neckties, most likely worn for the photograph) in any community school setting or cabinet-making factory. But instead, they labored without pay in a Pennhurst basement.

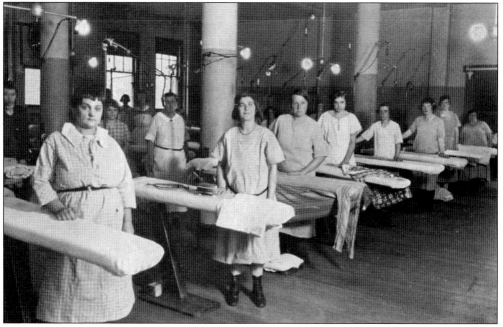

While this 1926 photograph is described as "vocational training," it appears to be the same room (with the same equipment) portrayed two years earlier as part of the laundry department. Where training ended and work began seems unclear, but what does seem clear is that the day-to-day experience of the "inmates" seemed to differ very little, no matter how it was labeled.

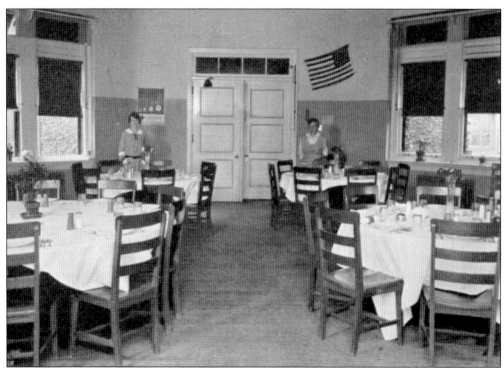

The contrast between the linen-covered tables in the officers' dining room (above), the attendants' dining room (below), and the endless rows of tables and chairs seen in the patients' dining hall (see page 33) is remarkable. These two rooms were located in the dietary complex, between the two larger "patient" dining rooms. The attendants' room was located in a basement below the officers' (doctors, nurses, and so forth) dining area, a not-so-subtle marker of the differences between the groups. "Working patients" were also employed here, waiting on the employees who were being paid to serve and support them. The servers' uniforms would have fit in perfectly in any nearby restaurant.

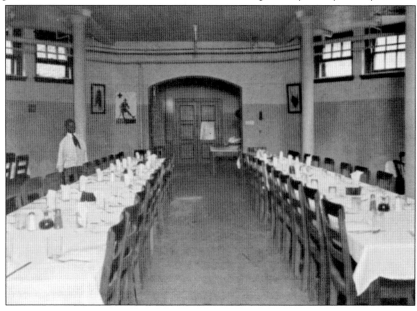

Four

THE SCHOOL

"School" became an official part of Pennhurst's name in 1923 when the legislature transformed the Eastern Pennsylvania Institution for the Feeble-Minded and Epileptic into the Pennhurst State School. While the original 1903 legislation enabling the construction of Pennhurst did not specifically mention the inclusion of an educational department within the institution, it is clear that the decision was made very early on to include a formal school program. In part, this might have been due to the fact that children with intellectual disabilities were routinely excluded from the public schools, a condition that would not change until a right-to-education lawsuit was settled in 1972. The fact that Pennhurst was primarily intended to provide for the "reception, detention, care and training" of children was memorialized in the establishing legislation, which directed the administration to "receive as inmates of said institution feeble-minded children, residents of this State, under the age of twenty years, who shall be incapable of receiving instruction in the common schools of this State." The exclusion of intellectually disabled children from their right to benefit from the free, public education provided as a matter of law to all other children was the factor that most often led to their admission to Pennhurst and other institutions that followed. The lawsuit that first established the right to education for all of Pennsylvania's children 70 years later, followed shortly thereafter by a federally guaranteed right to education for all children across the country, was one of the first steps that eventually led to the legal guarantee of community-based supports and the subsequent closure of Pennhurst and dozens of other institutions. While training was part of Pennhurst's original legislative charter, it was clearly directed toward the vocations needed for the operation of the facility by the "inmates." Academic instruction took second place and was available to only a few children. According to a later board report, "The school department started to function in the fall of 1909. Sense training, manual and vocational training and academic instruction were included in the first year's program."

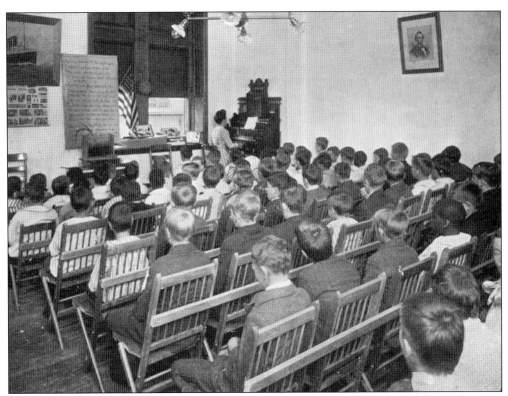

Pictured above is a 1912 school assembly. The classroom and the children look no different from any other school of that period, exacerbating the fact that this assembly was held in a world apart from the real world because society had decided that these children belonged elsewhere. The photograph below is a 1926 kindergarten class. Looking at these children, one has to ask why they were at the Pennhurst school and not one in their home communities. Did this school offer more than could be offered elsewhere? No, it did not. The only difference was that we decided that these children belonged here, not with their brothers and sisters at home. A free, appropriate public education would not be guaranteed to all children with intellectual disabilities until 1974.

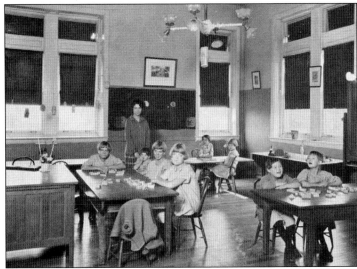

The 1922 board report included these photographs of an empty kindergarten classroom. Above, the room is decorated for Christmas. The classroom below is filled with ferns and other plants, presumably grown in the institution's greenhouses. It is noteworthy that the original gaslights had been converted to electricity in the decade and a half since the school building (Building R, later renamed Rockwell Hall) was constructed. Both images convey an ordinary setting, an ordinariness that was betrayed by the fact that the children who filled these little chairs would more than likely spend their entire lives at Pennhurst.

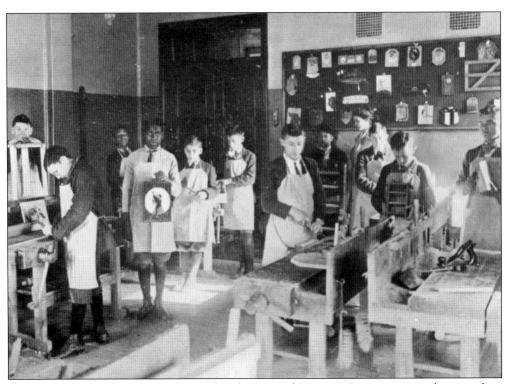

In one report, the chief physician stated, "The Manual Training Department is always a place of interest to the boys. They are taught the names, uses and care of tools, and learn to handle them properly by daily practice. They first make simple articles requiring no joints, such as match scratchers, coat hangers, etc. After they have mastered the rudiments of fitting and joining and can handle their tools with ease they are allowed to make small tables, chairs, tabourets, stools, settees, etc." The photograph above of manual training is from 1918. The 1922 photograph below is titled "kindergarten display room."

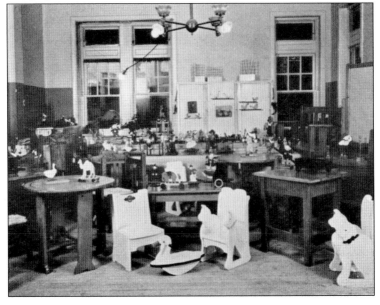

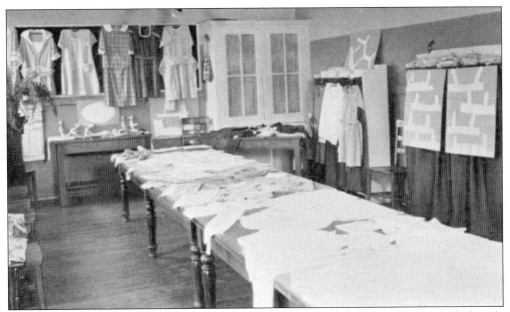

According to a 1940s information booklet, "Many beautiful and useful articles are made for sale to visitors and relatives; the profit from such sale going to the Children's Amusement Fund, out of which are purchased such little luxuries as Easter eggs, Christmas gifts, party prizes, etc." The photograph, captioned "dressmaking display room," is from the 1922 board report.

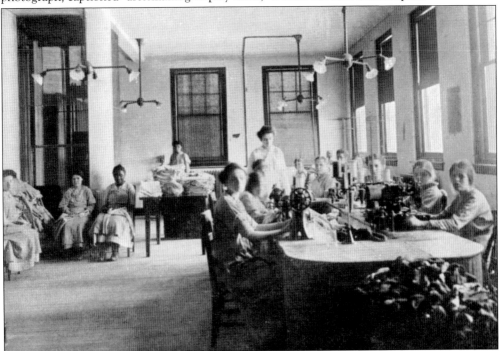

Many of the board reports listed large quantities of clothing made or repaired by the "patients," such as the items pictured in this 1916 sewing class. Beyond items for use and for sale, the 1918 board report also listed nearly 500 items, including pajamas, hospital shirts, drawers, and property bags sewn and donated to the Red Cross for the war effort.

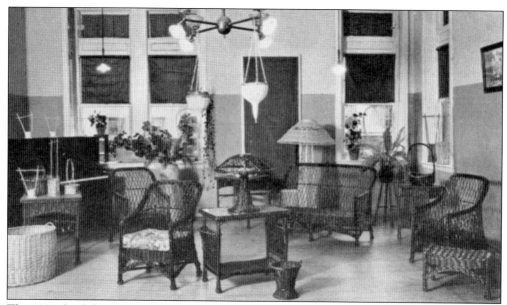

The 1916 chief physician's report noted, "A willow bolt was started this past spring from which we expect to obtain our supply of willow for our basketry department. The children planted the willow cuttings and cultivated the plot. They will harvest the willow, peel it, and then work it into the finished product." The quality of the willow work is aptly demonstrated in these two school display rooms. The effort was so successful that plant cuttings were later sent to other state facilities so they could follow suit. Numerous examples of willow furniture manufactured on-site were still in use until Pennhurst's closure.

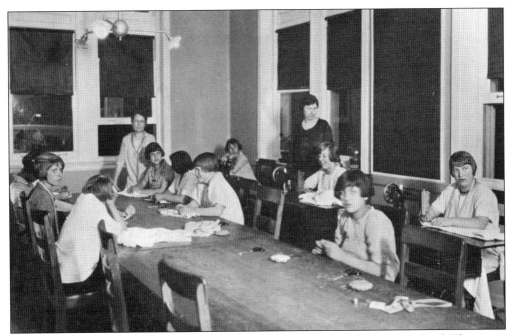

This photograph from the 1926 board report shows another sewing class in the school. The report revealed a significant change that year: "As an incentive for the children . . . 10% of the sales price of all articles sold is given to the individual making the article. The rest . . . is placed in a fund . . . for amusement purposes."

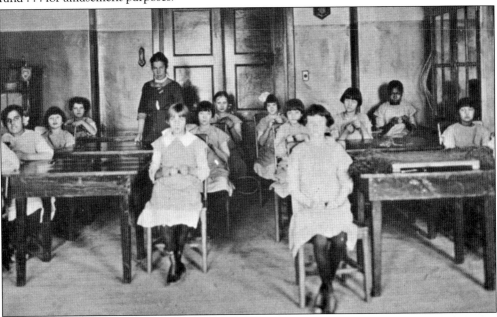

This c. 1918 photograph is another example of manual training in the art of basketry. It is interesting to note that only girls were included in this school class, while the willow workshop featured on page 58 employed only boys and men. Maintaining the separation of the sexes in the two decades before the introduction of the female colony was a continual problem, even carrying over into the work of the institution.

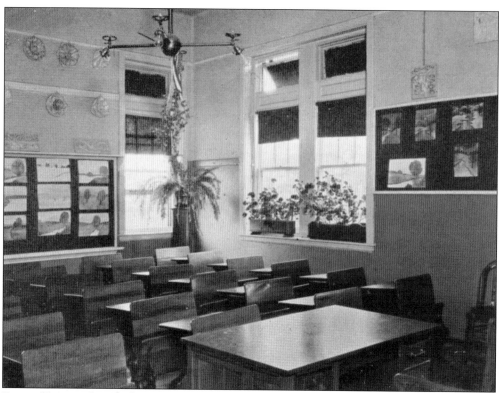

Pictured here in the 1922 board report are two more classrooms. The most remarkable thing about these images and those on the previous pages is how unremarkable these rooms are. A visitor to a local elementary school in Spring City or Royersford would have seen the same flags flying, the same planters in the windows, the same desks arranged in neat rows, the same student artwork decorating the walls. But the students who sat in these desks, who proudly hung their art, those students had been sent away from their families, had been segregated in an artificial world simply because society had decided that they were different.

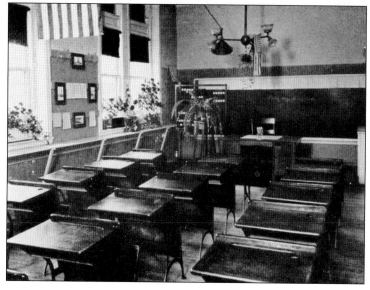

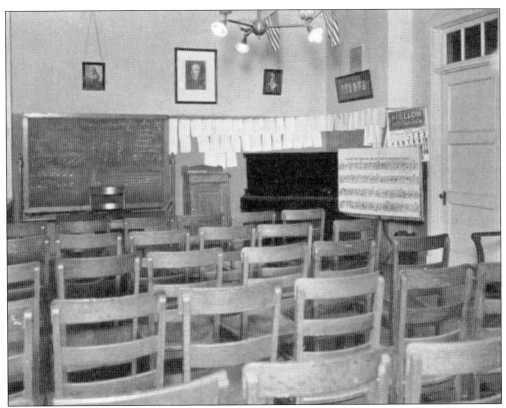

These images of other schoolrooms were also published in the 1922 board report. The image above is the music room, and the one below is the weaving room. It is unknown why the board decided to include photographs of empty schoolrooms in this report. All their earlier reports featured images of the children at work, dressed to the nines for picture day. Those other photographs are certainly more compelling, even if much of the message they convey is unspoken.

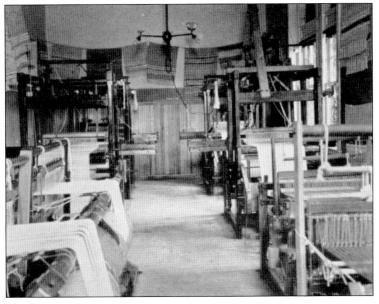

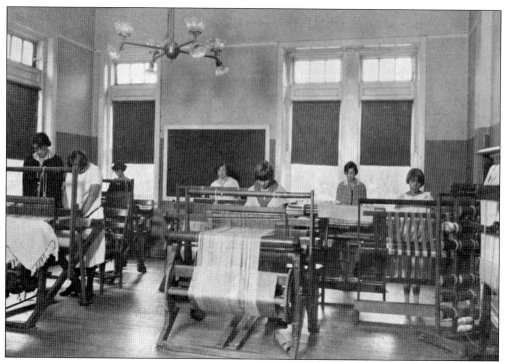

Many of the large looms pictured above were still in use through the end of the 1960s, and the rugs, runners, and tablecloths woven on them were in great demand. The production of woven goods finally came to an end when the individuals who were capable of setting up and using these complicated machines were given the opportunity to leave for new homes in the community. The rug-weaving class in the image below was located in the school building (R Building). A total of 11 "patients" were enrolled in the activity when this photograph was taken in 1926. As noted earlier, boys and girls were kept separate, even when being trained in rug making.

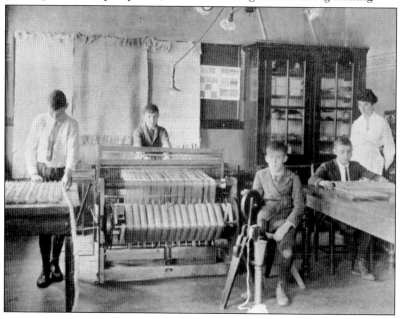

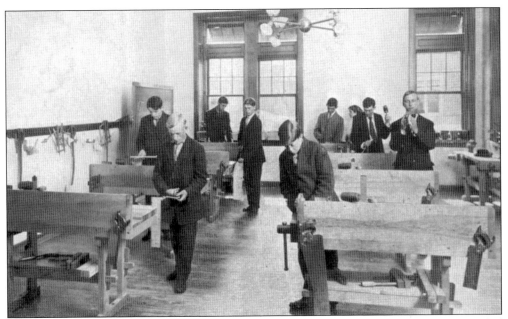

Sloyd work was a form of woodworking training originally pioneered in Sweden. It was intended to build the students' skills by introducing them to increasingly more complex and difficult projects. Items completed in the sloyd class were eventually sold. It was not until years after this 1912 photograph was taken that the students who made the items started to receive some payment for their work.

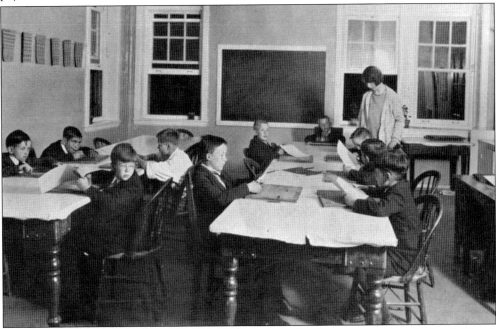

In 1916, it was noted, "We teach . . . the things we feel to be the most practical for the children's usefulness and happiness. It is necessary that their instruction be individual, with practical demonstration. The smaller children are started in our kindergarten and work up through the grades as far as they are able to go." This photograph appeared in the 1926 board report.

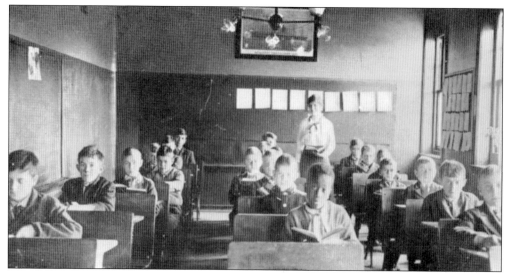

Accompanied by images from the 1918 report, the following quote is from the 1930 board report: "The number of children in school is now 400, including those receiving training on the wards. Here, as in other parts of the Institution, we are limited by the amount of funds that are available to us. We are making every endeavor to cull out those older boys and girls who have passed the age of sixteen and in this way enable the available teachers to give more of their effort and attention to the younger and lower-grade children. More can be done with this group of so-called low grades than is generally thought, but it requires more careful attention and training." The photograph above has been identified as a "primary English class," and the one below is a drawing class.

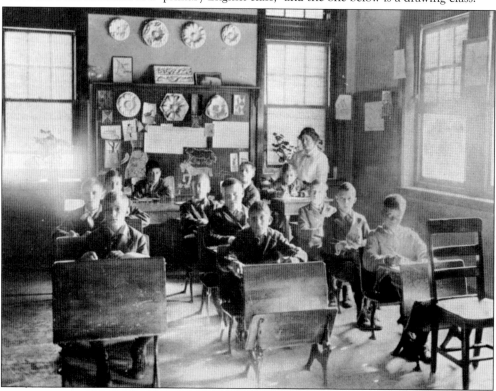

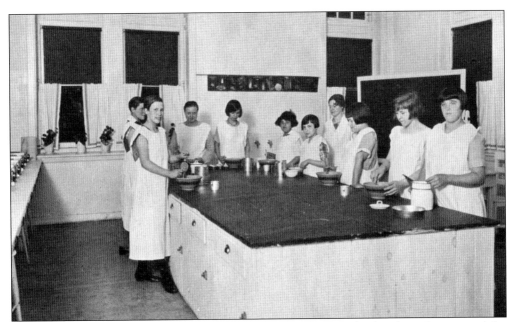

As noted in the 1954 information booklet, "At the age of fourteen the female students attend the Home Economic Department. At the completion of this course each girl should be capable of preparing and serving a complete meal. Much beneficial training such as pressing, mending, and sewing is given." By 1954, the equipment in the domestic science classroom had been upgraded. The photograph above is from the 1926 board report, and the image below is from 1954.

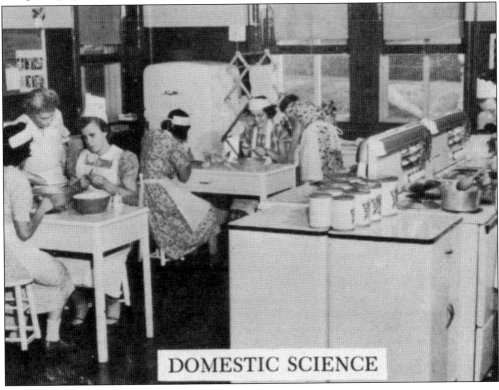

DOMESTIC SCIENCE

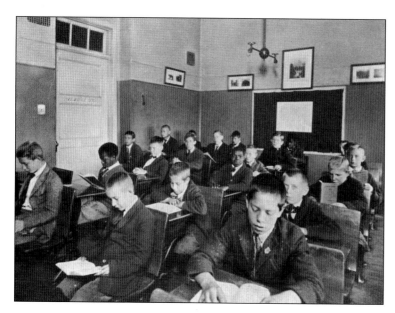

According to the 1918 board report, "The schools, manual and vocational training classes are in a good state of efficiency. We have a very capable group of teachers. The contentment and happiness of the children are largely due to the increasing efforts of those in charge of them and our corps of attendants deserve great credit for their care of the children."

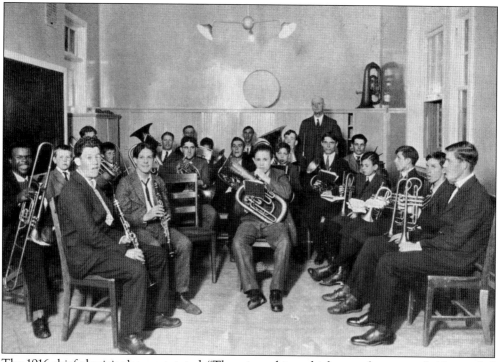

The 1916 chief physician's report stated, "There is nothing which appeals more to feeble-minded children than music. The musical department is one of the most interesting ones of the institution. The band of twenty pieces, under the direction of an experienced and capable instructor, has shown improvement during the past year far beyond the most sanguine expectations." This photograph was taken from the 1926 board report.

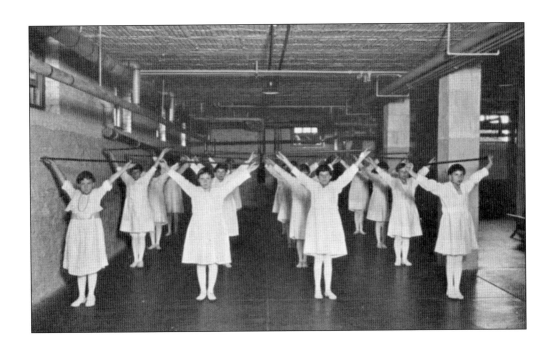

The 1918 board report claimed, "Feeble-minded children show not only a lack of mental development but they are deficient in bodily development. Physical training is therefore necessary and serviceable for both muscular growth and coordination." The two photographs of calisthenic exercise classes were published in the 1926 report. They would seem to belie the belief that "feeble-minded children . . . are deficient in bodily development."

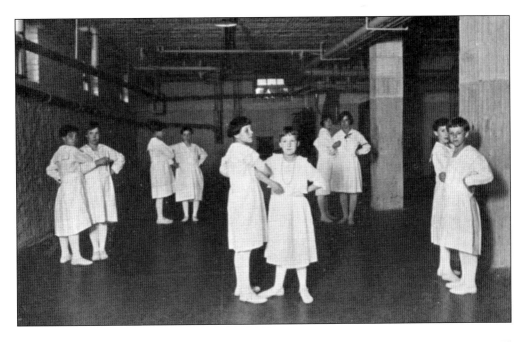

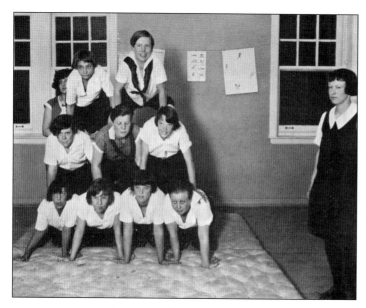

This 1926 photograph labeled "physical training—gymnastic work" is further proof that the "scientific opinion" about the development (and capabilities) of "feeble-minded" children was certainly not supported by the evidence. Once again, the saddest feature of this image is the fact that these smiling young women were forced to live in a separate world, apart from the wider one that should have welcomed them.

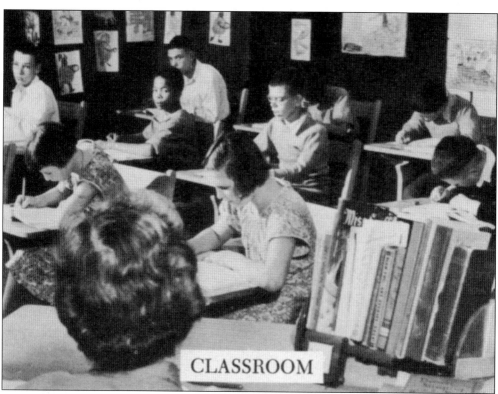

CLASSROOM

This 1954 classroom photograph was taken from that year's information booklet in which it was noted, "The school course extends from kindergarten to seventh grade inclusive and all students complete the course as long as satisfactory progress is maintained." How many of the 3,500 people living at Pennhurst that year had been given the chance to attend school is unknown.

These 1940s photographs show a singing class and another calisthenics class, this one for boys. Some of the boys doing their exercises are wearing Boy Scout uniforms. When these photographs were taken at the height of World War II, similar calisthenic classes were being conducted across the country for young boys who might soon be headed to war. While Pennhurst's "patients" were not considered capable of serving, the author is aware of at least one individual who ran away from the facility at the beginning of the war to join the Merchant Marines. The administration debated whether to have him arrested and returned, but they finally decided that he should be discharged because he was serving his country. It is unknown whether others followed in his footsteps.

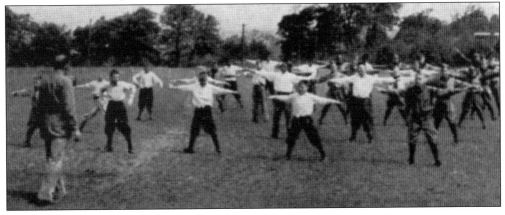

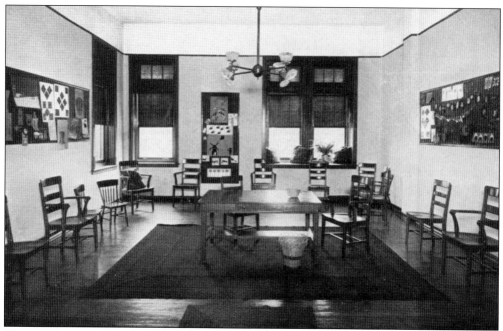

These 1912 images show the school's dayroom (above) and visitors' room (below). From June 1, 1910, to September 30, 1912, a total of 374 people were admitted to the facility. Of those individuals, 305 were age 20 or below; 106 of the newly admitted "inmates" were children under 10 years of age. How many of those children and adolescents benefited from the newly opened school is unknown. It is also unknown how many of them ended up spending the rest of their lives at Pennhurst. It is important to remember that the original 1908 facility was designed for 500 people. The number of people admitted during this two-year period demonstrates, as nothing else could, the overcrowding that plagued Pennhurst from the day it opened.

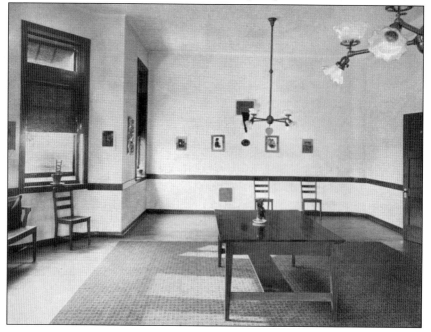

Five

THE PEOPLE
OF PENNHURST

During its lifetime and afterward, an institution is usually viewed as a collection of buildings, sometimes supplemented by a pile of photographs, thousands of documents, and for good or bad, a history captured in the headlines. Pennhurst is no different in that respect. But those physical remnants are not Pennhurst. Pennhurst was, and is, the people whose lives intersected with it. When the buildings fall down, the records turn to dust, and the stories are forgotten (or twisted into lurid ghost tales for the profit of others), the lives of the people remain. Those lives were not simply touched by Pennhurst—they were Pennhurst.

More than 10,600 people lived at Pennhurst during its eight decades of existence. Each person was given a number, from number one, admitted in November 1908, to the last person admitted in the late 1970s, when admissions were closed. Those 10,600 people had families and friends who cared about them, adding thousands of people to the Pennhurst community. And untold thousands more worked there, many for decades. It is impossible to know how many people were employed at Pennhurst. While the number of paid employees at a given time was often low, there were still many thousands of people who went to work there year in and year out. By 1980, Pennhurst had become one of the largest employers in the area, with over 1,800 workers. Added to this number were the volunteers, the local church and civic groups who filled a valuable role in building the world of Pennhurst. And there were hundreds of others who touched and were touched by Pennhurst—advocates, reporters, and those fighting to make it better.

It is impossible to make more than an educated guess at the total number of people who were part of the overall Pennhurst network. Certainly, it was more than 50,000. The exact number will remain unknown. What is known is that Pennhurst existed, not as buildings, but as a collection of people who left an imprint there and who were, in turn, marked by their experience of the place.

Information

PENNHURST

STATE SCHOOL

Commonwealth of Pennsylvania

Department of Welfare

This is the cover of an informational booklet published in the 1940s. It was aimed at the families of individuals already living at Pennhurst and those who were on the waiting list for admission. It was also designed to provide important information to social and welfare workers. Several pages were devoted to optimistic descriptions of the institution's programs. But it also contained three pages of rules covering visitation, written correspondence, telephone privileges, vacations, and even clothing. The pages describing the "patients" unwittingly revealed two of the more insidious aspects of society's view of individuals with intellectual disabilities at that time. First, healthy people were universally described as "patients," reinforcing the medical model of services. Second, all the people living at Pennhurst were perceived as perpetual children, despite the fact that many were adults who had spent decades there. Enforcing the image of the "patients" as perpetual children and denying their adult status was a not-so-subtle way of dehumanizing them.

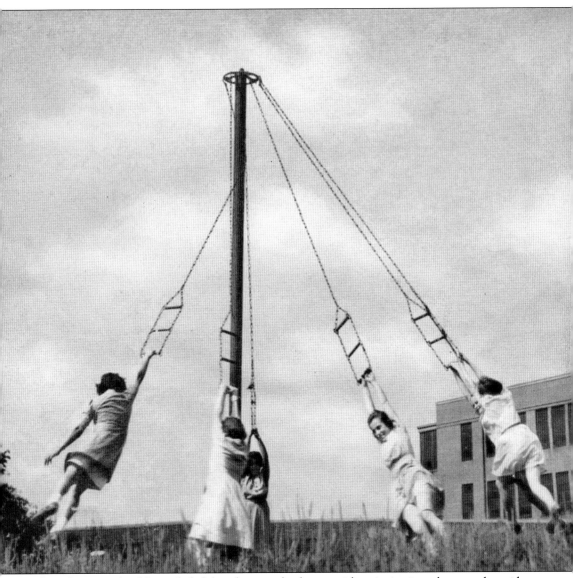

The information booklet included this photograph of young girls swinging in a playground outside their residence in the female colony. Their smiles are real; their joy in the day is obvious. But what if they had known a different world? What if the playground in which they played was in the neighborhood where their families lived? In the booklet, it was noted, "At least 90% of these children are happy the year round." Perhaps the saddest part of the Pennhurst story is never knowing how happy these girls might have been if society had not decided that they needed to be confined in a world apart.

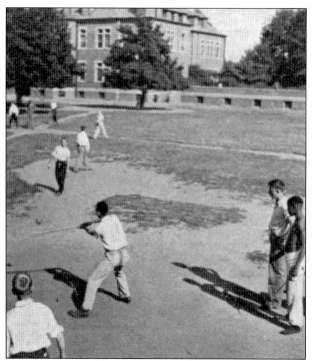

The booklet included these photographs on a page devoted to a description of the "patients." As noted, "The patient population is at present approximately 2,400 with a waiting list of nearly 1,500 due to the fact that the institution was filled to capacity. Boys and girls are about equally divided and live in two separate colonies. Children are admitted between the ages of six and sixteen . . . and while many must of necessity remain institutionalized beyond the age of 16, few remain after 40 years, some other arrangement usually being made with their county for further care." At left, L Building is visible in the background of the baseball game. Below, the "higher grade patients playing volleyball" are seen on the recreational fields between the main campus and the farm.

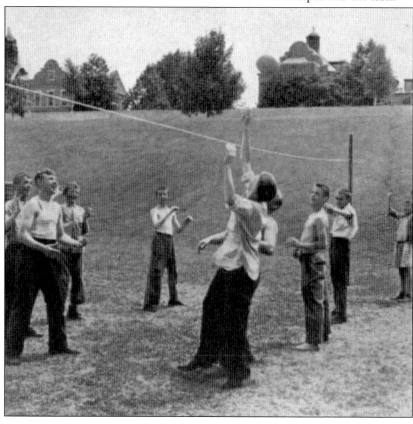

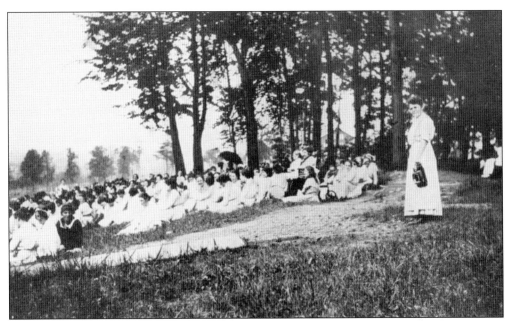

These photographs cover a span of more than 25 years. The image above, from the 1918 board report, is captioned "girls viewing ball game." The female colony would not be developed for another 10 years, so there was, of necessity, some degree of contact between the sexes, tightly controlled as it was. The 1940s image below features a group of young women enjoying an outing at the Valley Forge Park Dogwood Festival.

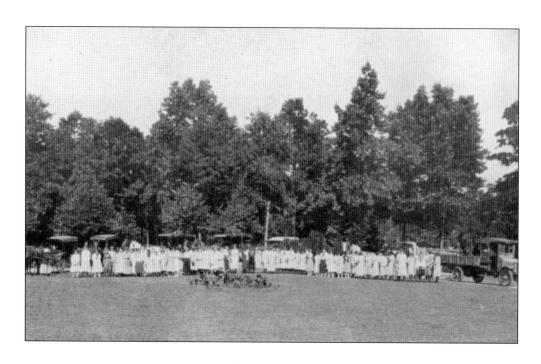

Pictured here are Pennhurst residents enjoying another outing, this time at Sanatoga Park. These images were included in the 1922 board report, which contained a list of events and outings, although few of the groups mentioned were as large as those pictured here. On September 12, "Thirty girls [were] taken to Sanatoga Park by Mrs. Scheerer." And on July 18, "Boys from the dairy, laundry, butcher-shop, power house and some of the farm boys were taken to Sanatoga Park under the supervision of Mr. Devlin." It is likely that these photographs capture those two trips.

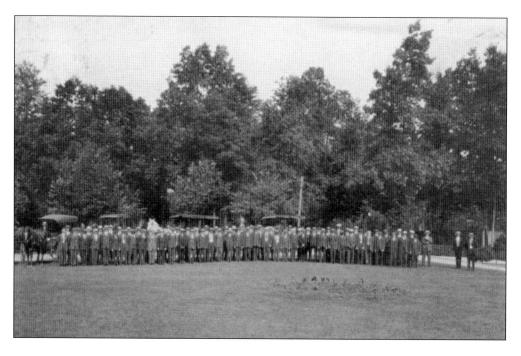

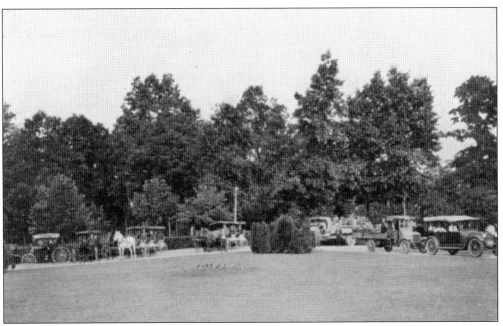

In another image of the male residents enjoying Sanatoga Park, it is interesting to note that their principal means of transport was horse-drawn carriages, along with a few farm trucks.

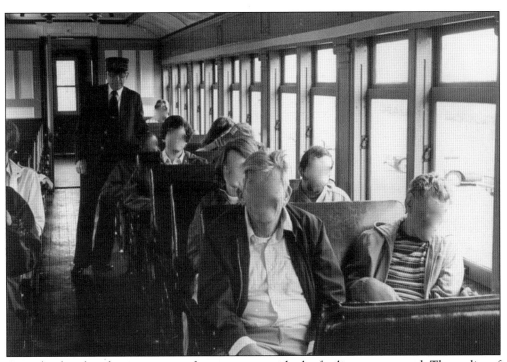

Over the decades, the excitement of excursions outside the facility never passed. The reality of life at Pennhurst was sometimes offset by the fun of a trip to a ball game, museum, zoo, or tourist railroad, as seen by this outing to the Strasburg Railroad in Lancaster County in the 1970s. The staff and volunteers who made these trips possible did so because they cared.

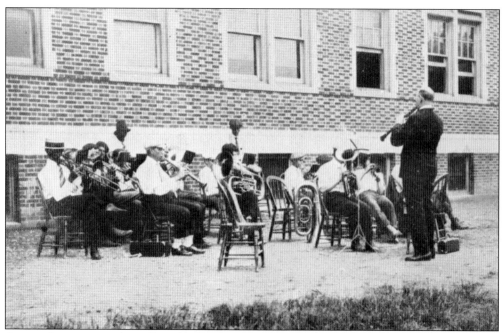

As stated across a number of board reports, "Music has grown in importance during recent years in institutions." That simple claim greatly understated the point. Music and the training of "inmates" to provide that music were central features of Pennhurst from the very beginning, as evidenced over the next pages. This photograph of the band is from 1918.

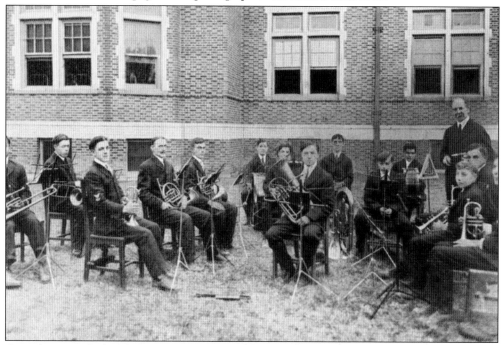

Over the years, the band played dozens of concerts throughout the area, at churches, schools, and community festivals. Gifts given for the band's services were placed in a special fund to purchase uniforms. This 1922 photograph shows that fundraising was very successful.

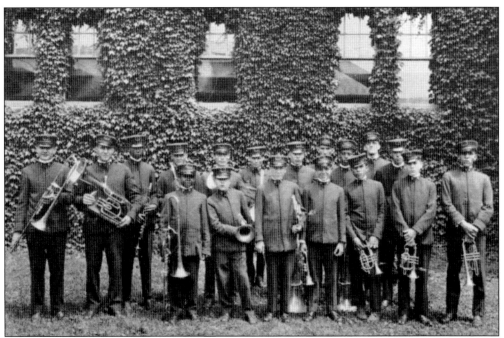

Among the concerts listed by the board was a November 1916 appearance to mark the "return of Battery C from the Mexico Border." Other appearances included a war savings drive in Spring City and a memorial exercise in Royersford, both in May 1918. While World War I might not have directly affected Pennhurst's people, they clearly played a role in the nation's response to it. These photographs are from 1922. By then, a women's orchestra had been formed to provide additional opportunities for musical expression. The board report for the two-year period of 1917–1918 once again lists multiple appearances by the "band boys." There are no community performances listed for the women's orchestra.

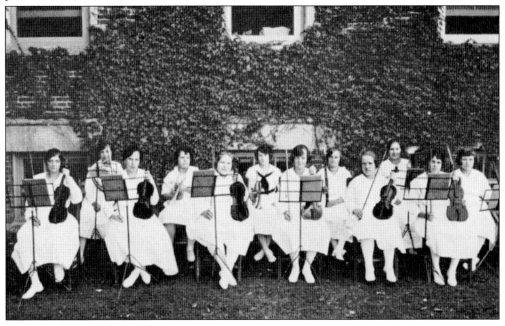

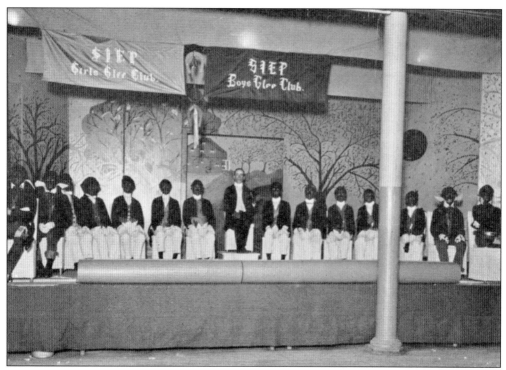

The presence of a blackface minstrel group was, unfortunately, not remarkable in 1922, when the photograph above was included in the biennial board report. As noted in the report, "All patients' gatherings, such as religious services, entertainments, dances, etc., have to be held . . . in the building's basement . . . The basements are poorly ventilated and overheated . . . These buildings are also so constructed that it is impossible for both sexes to attend amusements at the same time." By 1954, the minstrel group and other bands had been supplemented by the Western Band, pictured below.

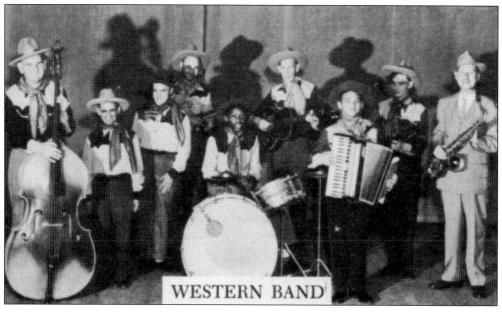

WESTERN BAND

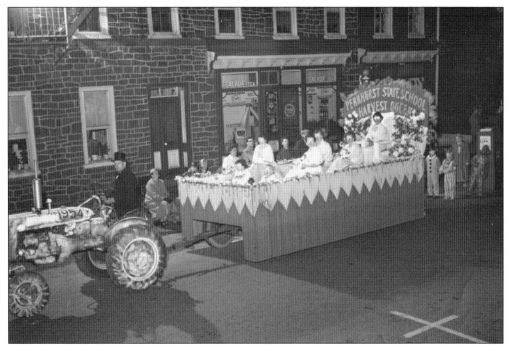

Even though Pennhurst remained isolated from the rest of society much of the time, the public side of the institution intersected with its local community in many ways, from the previously mentioned band concerts to baseball games and participation in annual festivals and parades. The "Harvest Queen" float appeared in the 1954 Halloween parade in Spring City, the community in which Pennhurst was located and where many of its employees lived. The photograph below of the "Harvest Time" float is from the same parade.

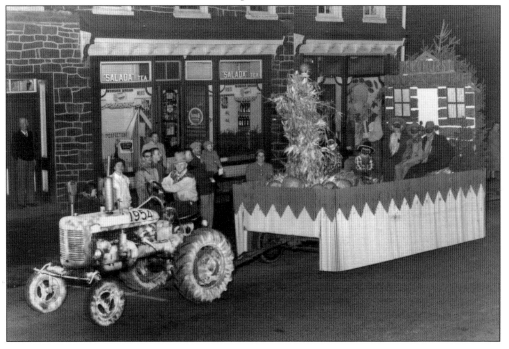

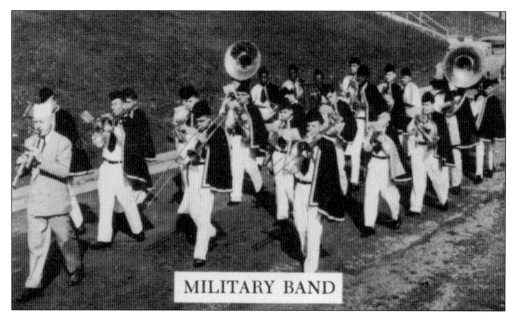

MILITARY BAND

The Military Band reinforced the continuing presence of music as an important part of life at Pennhurst. As described in 1954, the Military Band, which would expand from 28 to 50 members, was "popular throughout the institution and nearby communities playing many engagements for events and holiday celebrations."

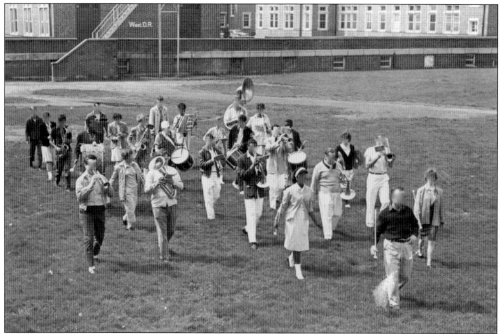

The members of the band continued to rehearse and perform together even as the world changed around them and as many of the band's members were finally given the opportunity to move on from Pennhurst. This undated photograph from the late 1950s or early 1960s shows the dedication of the group, still working together without any apparent direction or involvement from the paid bandmaster.

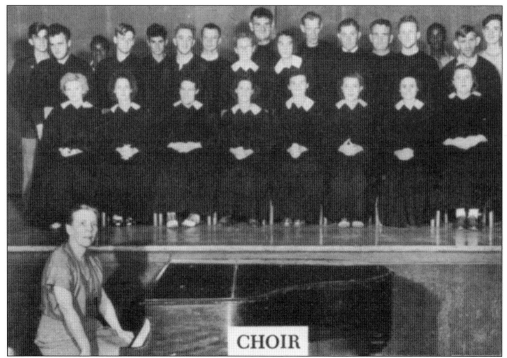

CHOIR

In 1954, there was "a mixed choir of 26 boys and girls" and "a chorus of 22 boys and girls who sing for the various entertainments and programs," as well as "a colored choir of 16 boys and girls [who] sing regularly for church services." No photograph of the latter group was included in the booklet, however.

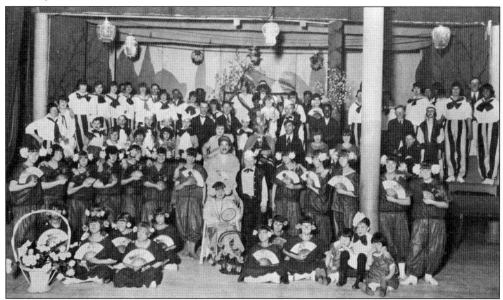

The 1926 board report, in which this image was published, stated, "In the two Christmas celebrations held during the period covered by this report, the personal desires of the inmates were taken into consideration, and each patient received at least one gift that they asked for, as well as gifts of candy, fruit, etc. Entertainments and special dinners were part of the Christmas festivities."

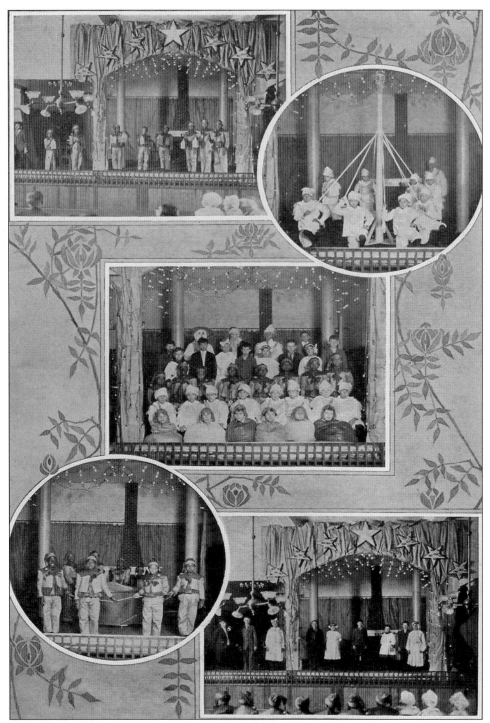

No caption is really needed for this collage of the 1912 *Christmas Cantata: The Capture of Santa Claus* other than to note that "all excepting one person are inmates." The sweetness of the photographs and the effort put into the production speak for themselves. That still leaves the question as to why. Why were these children confined in a separate world?

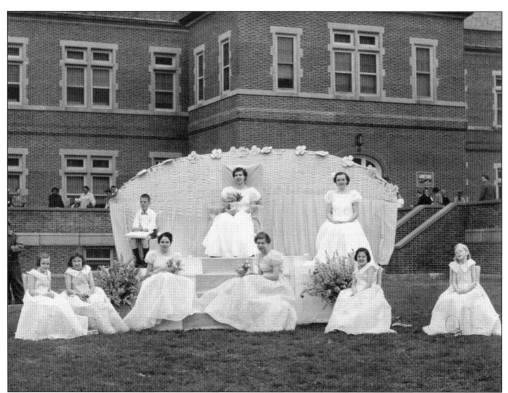

Just as in the wider world, the May Festival was a much anticipated annual activity, signaling as it did the end of winter and the beginning of summer. This photograph dates from the early 1950s and might have been an outtake from the 1954 information booklet.

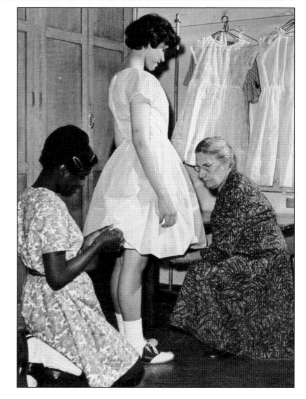

Young women at Pennhurst looked forward to picking out that perfect dress for the next big dance just as much as their peers in the wider community. While limited in number, coed activities did occur at Pennhurst, even though segregation of the sexes remained of paramount importance until 1970.

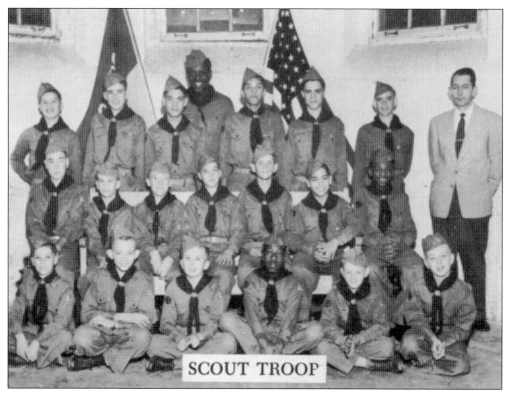

SCOUT TROOP

The Pennhurst Scout troop was featured in the 1954 booklet. Pennhurst's troop functioned exactly the same as all other scouting groups, with one exception. Participants were not required to age out of the group as they grew into adulthood. As with many of the other activities that involved the most capable people living at Pennhurst, the Scout troop was eventually dropped as these people were given the chance to reclaim a life in the real world.

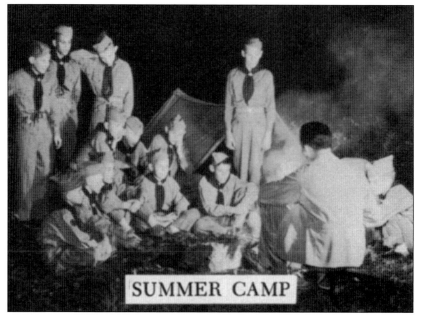

SUMMER CAMP

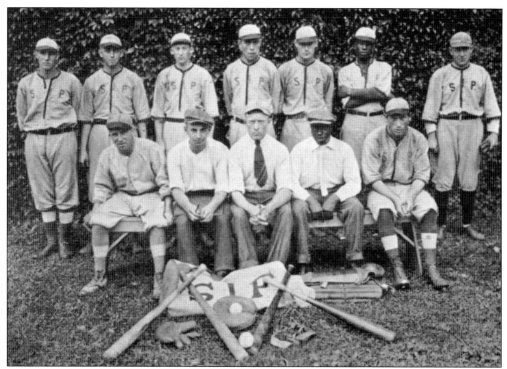

From its outset, Pennhurst fielded an "inmates" baseball team. The photograph above shows the 1922 team, and below is the 1925 team, seated on the front steps of the administration building. When viewing these images out of context, one would not identify these players as "different." All there is to see is a great-looking team, filled with the proud faces of the players. The most astonishing aspect of these images is the integrated team, which was uncommon at that time.

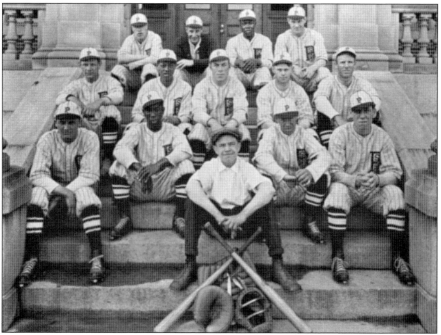

For many years, Pennhurst hosted the Hoxie Brothers Circus for a one-day appearance on campus. Reportedly, some Pennhurst residents took the opportunity to join the circus during these annual visits. Whether the administration tried to reclaim these "runaways" is unknown. Bringing the circus to Pennhurst eventually ended in the mid-1970s, when it became obvious that excursions to the circus made so much more sense.

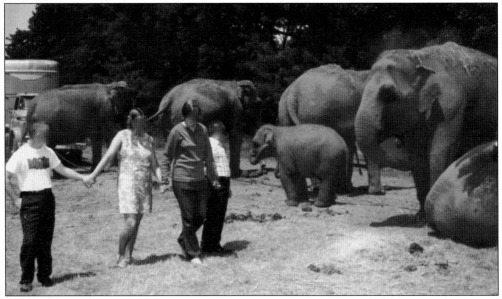

The overnight appearance of a real three-ring circus on the fields below the male campus must have seemed magical for both the residents and staff. In many ways, bringing the big top to Pennhurst illustrated the dissonance between the wonder of a circus and the reality of the institution. But there it was, elephants and all.

Holiday parties and band concerts were as much a part of Pennhurst as they were in the outside world. Easter egg hunts with the Easter Bunny in attendance, Halloween parties featuring a dancing "Great Pumpkin," and many other activities filled the calendar. Even though few, if any, would have chosen to spend their lives at Pennhurst, that does not mean that each life spent there was desolate and grim.

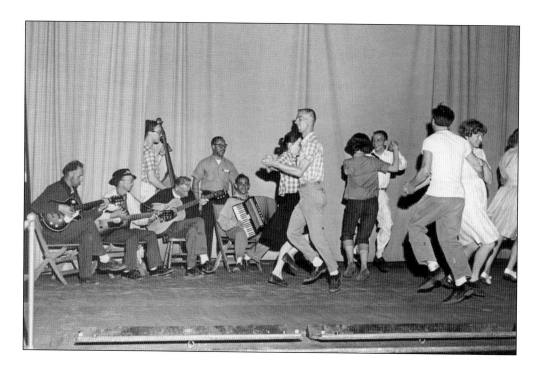

Concerts by volunteer musical groups were also year-round highlights, whether the performers were a country and western group playing for a hoedown on the auditorium stage in the early 1960s or a local garage band playing on the picnic grove stage in the 1980s.

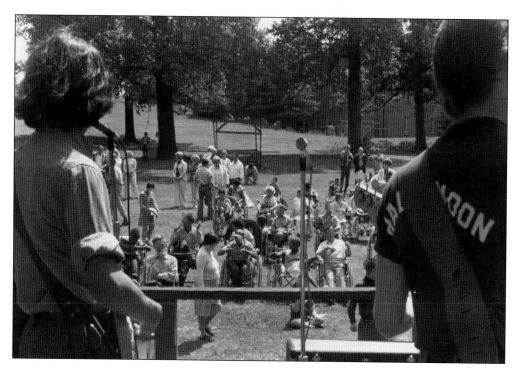

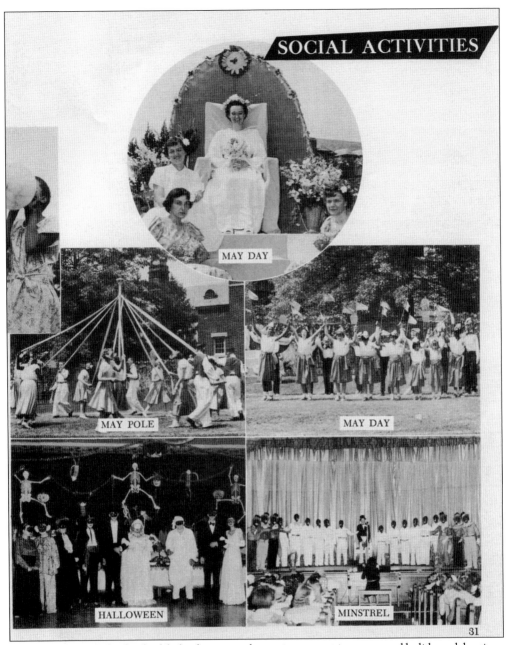

MAY DAY

MAY POLE

MAY DAY

HALLOWEEN

MINSTREL

31

These 1954 images further highlight the carnivals, parties, entertainments, and holiday celebrations that brought pleasure and fun to the day-to-day life of Pennhurst. It is interesting that the minstrel group was still performing that year, at the beginning of the civil rights movement.

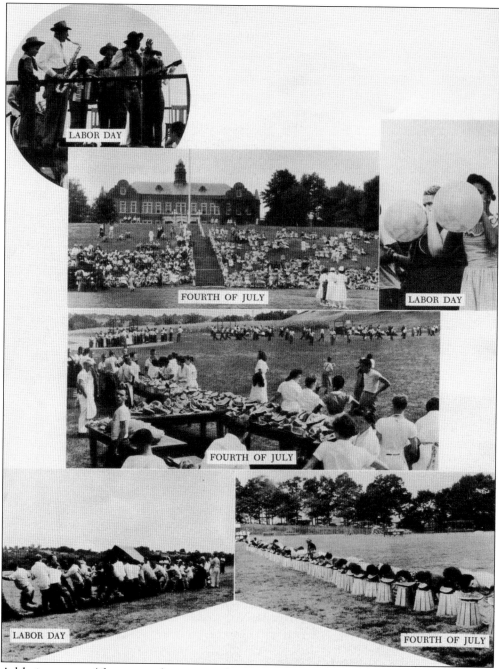

Athletic contests (if one considers watermelon eating a sport) and musical performances filled the holidays in these 1954 pictures.

Everyone who entered Pennhurst brought a unique history and an unknown future. The boy in these photographs is Martin New, seen with his father on admission day. Why Martin's family had to place him at Pennhurst is unknown, but he was lucky. His family stayed connected to him through the decades. While it is not known why he was admitted, Martin moved to a community home in June 1978 after his 30-plus years at Pennhurst. He was given this opportunity when Pennsylvania decided that homes in the community were preferable to institutions. Martin's move also coincided with a landmark legal ruling that established a right to life in the community. Martin's life after Pennhurst lasted until his death two decades after his move. (Both, the Martin New family.)

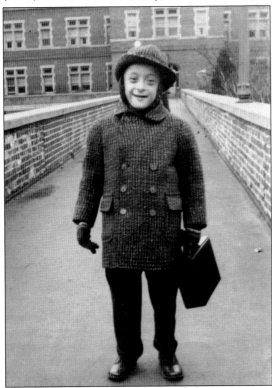

Roland Johnson's
LOST IN A DESERT WORLD

An Autobiography
(as told to Karl Williams)

The Pennhurst story is truly the story of the people who lived there; Roland Johnson was one of those people. Admitted to Pennhurst in 1958 at the age of 12, Johnson saw a decade go by before he was able to leave for a new life in the community. But Johnson turned his time at Pennhurst into a triumph. He understood that others needed to hear what happened to the hundreds of thousands of people sent to institutions across the country. Johnson's words, captured in his book *Lost in a Desert World*, offer stark, powerful descriptions of his years at Pennhurst—and say more than anyone else could about the terrible mistake made by society when it created these separate worlds. (Both, Karl Williams.)

Roland Johnson took the anger, fear, and frustration from his years at Pennhurst and turned it into something positive through his work with Speaking For Ourselves (SFO), one of the first advocacy organizations created and run by individuals with intellectual disabilities. Before this, advocacy had been enacted only by parents and professionals. Johnson and the members of SFO brought a new voice to the table, a new viewpoint—based on the lives that he and his peers lived, as well as their own aspirations and dreams. Roland Johnson died in 1994. His legacy lives on in the philosophy of the self-advocacy movement: "Nothing about us without us." The central tenet of the self-advocacy movement is the people with the greatest stake in the service system, those who receive services, must always be involved in all planning and decision making on both an individual and systemic basis. Needless to say, this is a significant change from the past, when the "professionals" made all the decisions. (Above, James Conroy; right, Karl Williams.)

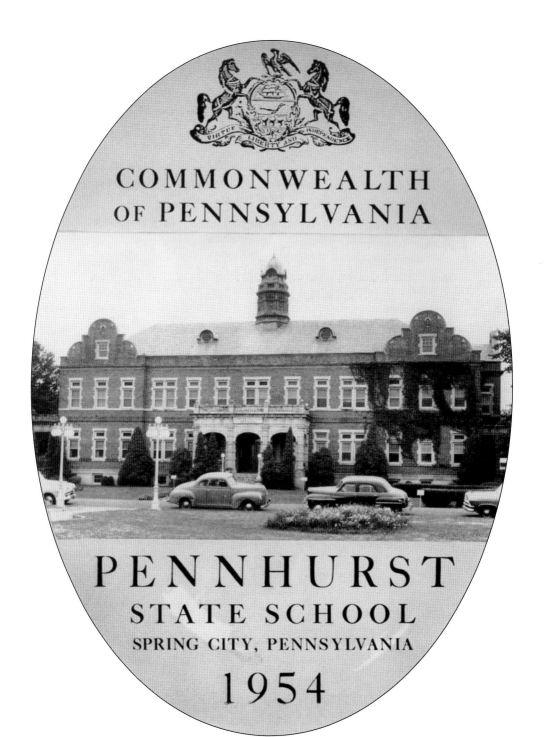

COMMONWEALTH
OF PENNSYLVANIA

PENNHURST
STATE SCHOOL
SPRING CITY, PENNSYLVANIA
1954

In 1954, the Pennhurst administration decided that another booklet describing and explaining the purpose of the institution was needed. The idyllic cover shot of the administration building continued the practice of highlighting the positive attributes and ignoring the reality of the hidden Pennhurst, the one overcrowded with the "helpless and hopeless" for whom providing care was an enormous problem.

Six

THE UNSEEN PENNHURST

There were two Pennhursts from the beginning. The legislature created them when they directed that "the buildings shall be in two groups, one for the educational and industrial department and one for the custodial or asylum department." While both Pennhursts operated apart from the rest of society, there was some public awareness of the educational and industrial department, as evidenced in the photographs included thus far. In their public reports, the board bragged about their successes in turning profits on the farm, fielding musical groups and baseball teams, and educating those children who were deemed capable of learning. But the reports and the informational booklets published in later years rendered the second Pennhurst, the custodial or asylum department, invisible. That invisibility, fueled by the belief that some people were helpless, without hope of any meaningful life, allowed unfavorable conditions to grow and fester, conditions that caused a public outcry each time they were exposed in one or another recurring scandals. Tragically, those scandals did not lead to meaningful change, because the underlying philosophy did not change. If there was no hope for the individuals in the "custodial department" to improve, what was the point of trying to improve the place in which they lived? As each scandal waned, the invisible half of Pennhurst slipped away from the public's consciousness, out of sight and out of mind, and little changed.

The recurring nature of problems was highlighted in a 1930 report, written less than 22 years after the institution opened. The superintendent provided a statement in regard to the improved sanitary conditions since his arrival: "A program of general cleanliness . . . has been entered upon at Pennhurst. It includes not only cleanliness of the individual patient, but also of all of the things that come in contact with him, which has necessitated the purchase of more clothing, beds, bedding and furniture, and also vast quantities of paint, the putting down of new floors, the reconstruction of various wards . . . through the tearing down of walls." The very invisibility of this second Pennhurst means there are few images to document it. Those that do exist are often disturbing.

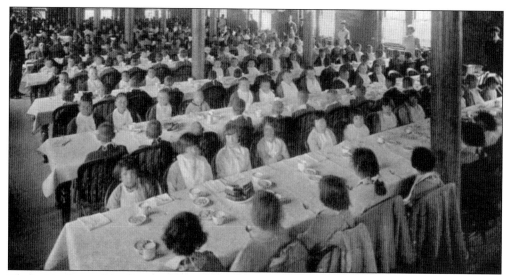

The image above of the "inmates' dining room" was published in the 1916 board report. Its inclusion is apparent evidence that no one found anything objectionable to the sight of hundreds of people, most of them children, lined up at table after table, waiting for a meal. Pennhurst had been open only eight years, but the population was already more than 900, despite the fact that the initial legislative appropriation called for the construction of an "institution to accommodate not less than 500 inmates or patients." The photograph below was included in the 1912 board report, only four years after Pennhurst opened. Again, one can only assume that the conditions of overcrowding and depersonalization that are so evident did not raise any concern when it was published.

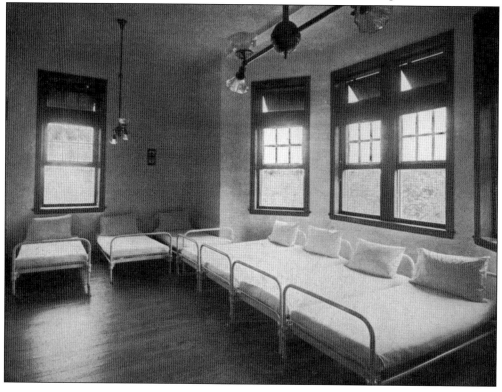

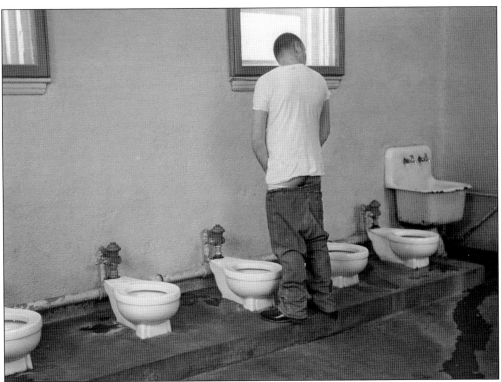

The undated photograph above was presumably taken in the late 1960s or early 1970s. Pennhurst's administrators likely used it to demonstrate the need for funds to alleviate the conditions shown. Those conditions persisted in most buildings for another decade and were addressed only after federal funding became available. Those funds were tied to a detailed set of standards, including privacy, limits on the number of people living in a given area, and the provision of actual treatment for all. It is noteworthy that the 1926 board report included the following comment: "Buildings U – V – T and Q . . . have very crude, antiquated, unsanitary, inefficient and decidedly odiferous toilet systems." How much of an improvement the facilities in use in 1970 were over those impugned in 1926 is unknown. The image below was taken in 1975.

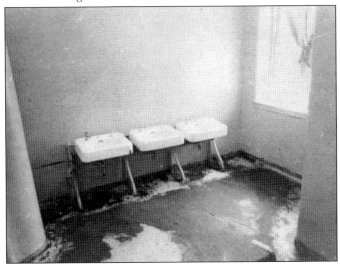

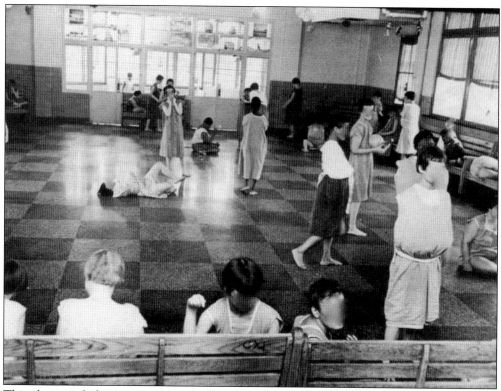

This photograph from 1968 was tragically representative of life for those individuals who were deemed in need of custodial care. Enforced idleness and neglect often led to the development of challenging behaviors, challenges that were met by the use of restraints. This is the Pennhurst where the author began working in 1969. Many of the women in this photograph eventually became his responsibility (and his friends).

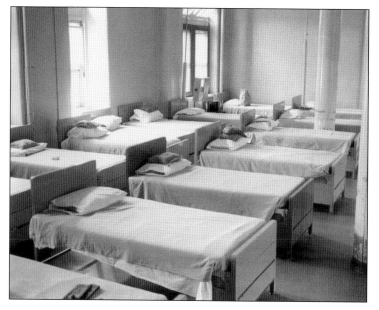

These sleeping quarters in Ward 2 of the D Building (Devon Hall 2) were photographed in 1975. Peonage had been outlawed in 1972, so many of the "working patients" who lived here had little to do each day. D Building was the largest structure on the original campus. In 1955, each of the four wards in the building held 105 people. That number had changed little by 1975.

Pictured here is a bathroom in K Building in 1975. The conditions in this room had not changed in decades, because the funds needed to upgrade the facilities were never made available, despite many exposés to the contrary. K Building was the only residential building to be demolished, coming down in the late 1970s.

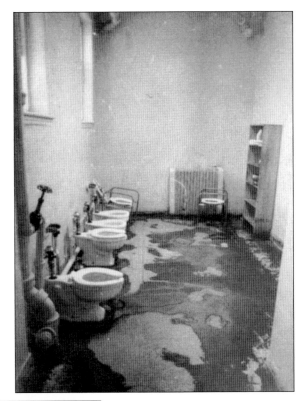

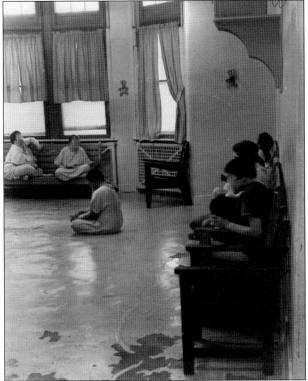

This image from 1971 details both the physical conditions in the living areas and the enforced idleness that was the result of too few staff to provide meaningful activities and programs for all residents.

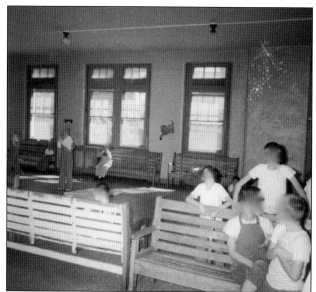

One of the first rules spelled out to employees was that photography was strictly prohibited. Despite that ban, someone took a series of photographs documenting the living conditions in the custodial department in 1967–1968. Who or why they did it is unknown. The images made their way into the author's possession sometime after Pennhurst closed, and they are reproduced here for the first time.

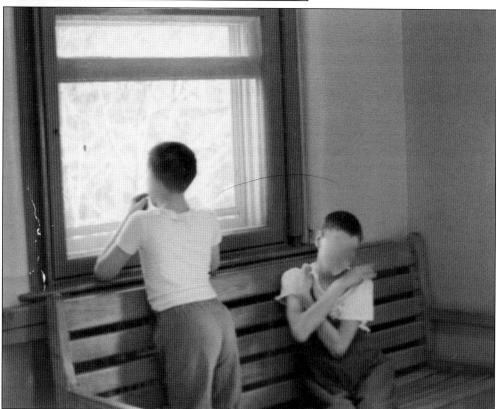

These two boys were not in school in 1968 because Pennhurst was just like the rest of the country; children who were deemed uneducable were routinely excluded from school, just as they were in the community at large. This policy changed in 1972 when Pennsylvania conceded that all children were entitled to a free public education. Two years later, Pennsylvania's decision became the model for the federal right-to-education legislation.

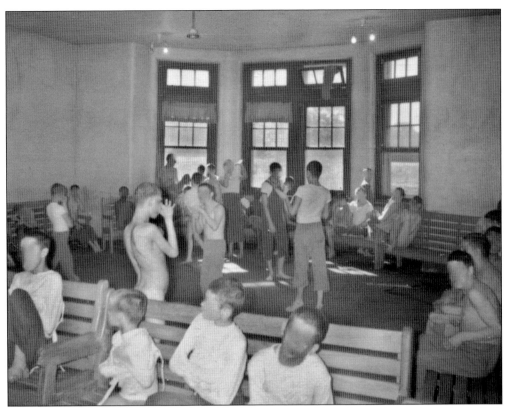

Captions seem unnecessary here. The faces of those pictured have been obscured to protect their privacy. As in the earlier photograph of a women's dayroom, the author came to know and work with several of these people. The fact that they were eventually able to leave Pennhurst and move back to the "real world" is the part of his career of which he is most proud.

This is another unauthorized photograph from 1967. Only one employee can be seen in the photograph. At this time, it was not uncommon for no more than two attendants to be assigned to a residence, housing anywhere from 50 to 100 individuals. The actual care and supervision of the residents was carried out by "work boys and girls."

This is the view from M2, the second floor of the M Building. Because of the lack of staff and the paucity of activities for individuals who were not in school or enlisted as "working patients," an open window was often the only connection to the outside that people enjoyed on a day-to-day basis. It is important to remember that the enforced idleness and neglect that characterized Pennhurst was the inevitable result of society's decision to lock "different" people away.

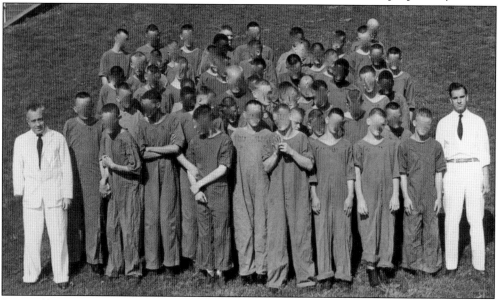

Pictured here is a group portrait taken in the late 1950s. The facility was required to purchase the residents' clothing from Correctional Industries, and any individual who desired to wear his or her own clothing was responsible for taking care of it. State clothing was processed through the institutional laundry and not owned by any individual. If one was lucky, there was something in the proper size on the shelf each day.

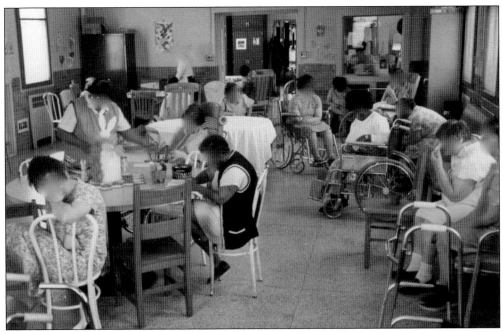

This photograph of a dayroom in Female Building No. 2 (later renamed Buchanan Hall) was taken in the mid-1970s. Prior to the end of peonage, the efforts of the two employees seen here would have been supplemented by "working girls." The lack of resources needed to provide meaningful lives for people had still not been addressed. That would come, but it would take time.

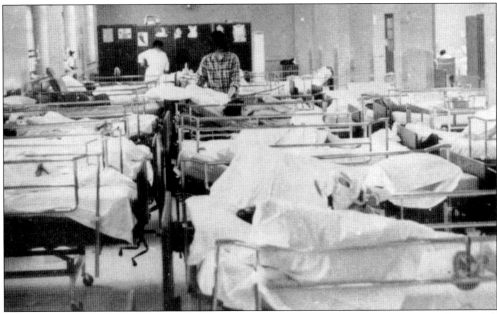

This photograph was one of many taken by FBI agents prior to the *Halderman v. Pennhurst* trial. Presented as evidence, these images and others like them played a major role in Judge Raymond Broderick's determination that fixing conditions at Pennhurst would never be enough to remedy the human rights violations of Pennhurst's people. Only life outside of a large congregate setting would be sufficient.

Over the years, Pennhurst was entangled in several lawsuits. The most significant was *Halderman v. Pennhurst*, which was argued twice before the US Supreme Court. The Third Circuit Historical Society chose Pennhurst as one of the most important cases ever tried in that court, and it is acknowledged as the first of the cases that eventually established the right of people with disabilities to receive services in community settings.

One of the most significant aspects of Pennhurst's closing was a study funded by the Department of Health and Human Services to measure the impact of the closure on the people who lived there. The study found that, in every facet of their lives, the movement from Pennhurst to the community was overwhelmingly successful. The results of the study have been shared across the country and around the world.

THE PENNHURST LONGITUDINAL STUDY

combined report of five years of research and analysis

EXECUTIVE SUMMARY

Seven

After the Doors Closed

It has been more than 25 years since the last residents of Pennhurst left for new lives in the community. The fate of the institution has been mixed and controversial, much as it was during its life. A portion of the campus was repurposed as a home for veterans, operated by the Pennsylvania Department of Military and Veterans Affairs. A portion of the upper campus is now home to a National Guard armory. The unit stationed there was deployed to Iraq and remains an active part of the nation's armed forces. A large tract of former farmland adjacent to the upper campus buildings has been deeded to East Vincent Township, which intends to develop the land, including the small Pennhurst cemetery, into a park.

The status of the original campus is more discouraging. Once the facility closed, it became a favorite destination for urban explorers, drawn by the notoriety of the campus and notions of adventure. It also became a target of scrappers looking for any salvage that could be turned into money. The theft of the copper sheathing from the lower portion of the administration building cupola is the most visible outcome of this criminal activity. Since the original campus was sold in 2008, most of the buildings have continued their slide into demolition through neglect. An effort to creatively reuse the campus has been unsuccessful. A dream of building a museum that would tell the story of society's treatment of people with disabilities has all but been abandoned, but it has led to other efforts to ensure that the sad history captured at Pennhurst and other facilities is not lost. Keeping the history alive is the best way to ensure that the mistakes made there are never repeated. It is also the best way to respect the memories of the lives spent there. While a museum may or may not be built at Pennhurst, it is hoped that it will eventually be erected as a reminder of how society treated those labeled as "different."

Pictured here is the cupola on the administration building after the first level of copper sheathing was stripped off by scrappers. Reportedly, the individuals who committed this act of vandalism made a video of their crime and posted it to YouTube, which led to their arrest. This photograph is titled *Perseverance*. (Copyright © by Daimon Paul.)

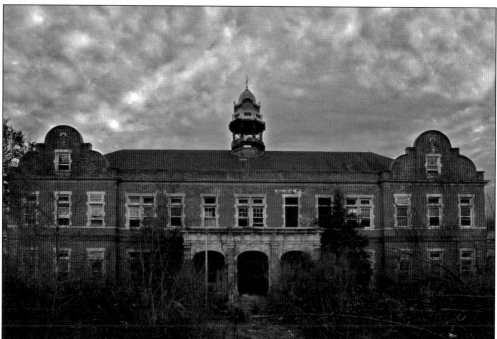

After Pennhurst closed, the devastated administration building become a symbol of the neglect and vandalism that plagued the campus. This photograph was taken in 2008. (Copyright © by Fred Everett.)

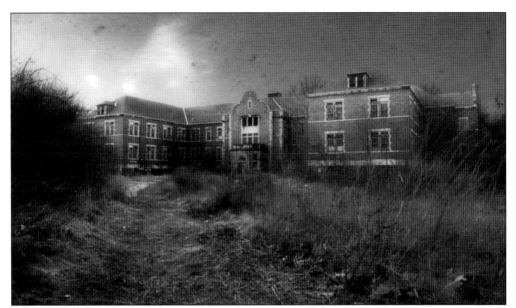

Devon Hall was the last building erected on the original campus. Construction began before World War II but was halted until the war ended. Devon Hall was the largest building on the lower campus, housing nearly 450 people in the 1950s. When modern standards were applied in the 1970s, the capacity was lowered to less than 100 people. This photograph is titled *The Path*. (Copyright © by Fred Everett.)

The partitions in the background of this interior view of Devon Hall were installed in the 1980s. Designed to provide privacy and personal space for residents, they divided the large wards into smaller bedrooms for three or four individuals. (Copyright © by Daimon Paul.)

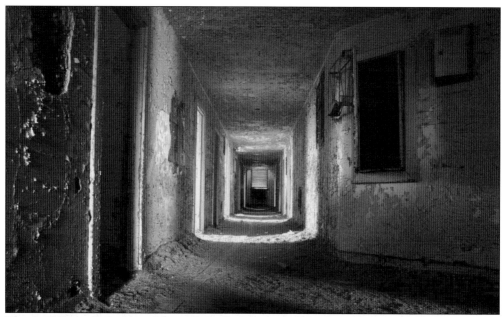

The third floor of L Building (Limerick Hall) was originally used for staff housing during the years when employees were required to live on campus. After it was no longer needed for employees, it became a residential area, considered one of the best places to live because it was free of the overcrowding found elsewhere and provided privacy for those who lived there. (Copyright © by Daimon Paul.)

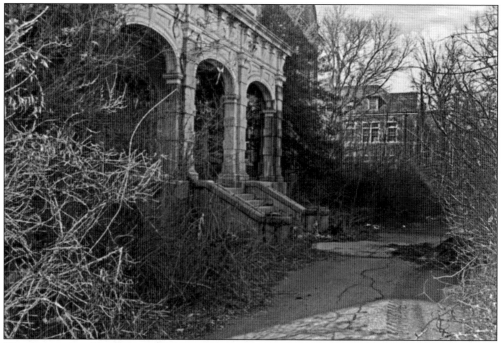

The concrete railings originally located between the columns of the administration building were toppled to the ground by vandals. L Building (Limerick Hall) is visible in the background. (Copyright © by John Bendel.)

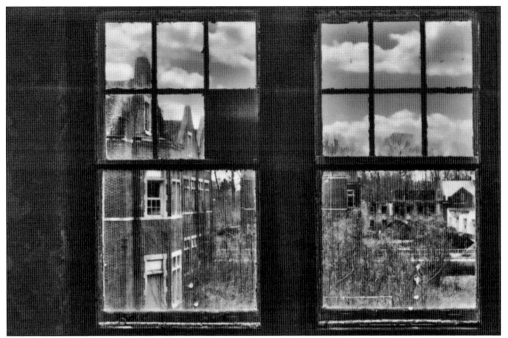

This compelling image shows the view across the quadrangle toward Rockwell Hall and the dietary building, with the unroofed maintenance and storeroom building beyond. Like many of these contemporary images, it goes beyond simple documentation of the site and becomes art. (Copyright © by Emery Roth II.)

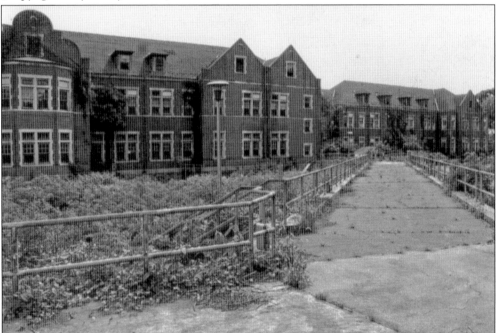

Pictured here is the walkway leading from the hospital (not pictured) toward Industry and Hershey Halls. The large empty space on the left is the site of the demolished K Building. (Copyright © by John Bendel.)

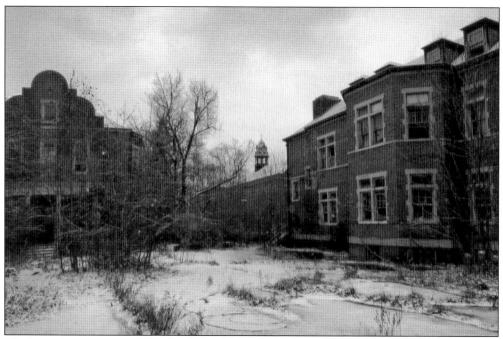

This winter scene encompasses the Philadelphia Building to the left, Mayflower Hall on the right, and the administration building in the background. Quaker Hall (not pictured) completed the trio of buildings that surrounded this parking lot. (Copyright © by Marc Reed.)

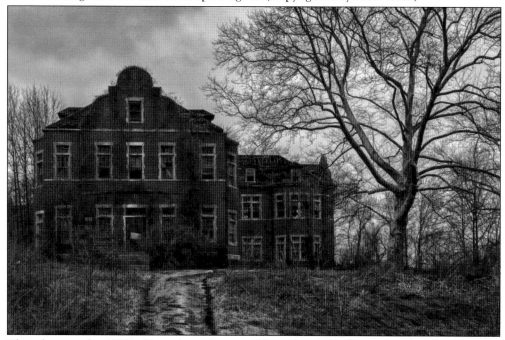

This photograph of U Building shows how quickly and completely an abandoned facility can become overgrown. U Building was one of the earliest decommissioned buildings when Pennhurst's population began to shrink. It was used for storage of excess furniture from the early 1970s until closure. (Copyright © by Emery Roth II.)

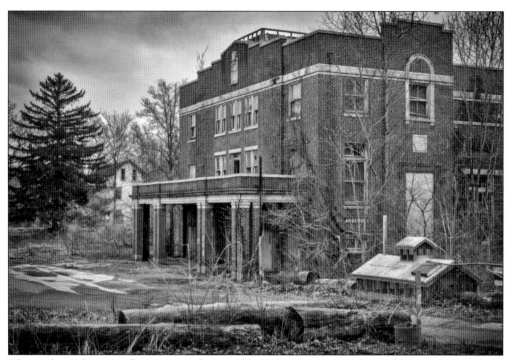

This is the auditorium (later renamed Assembly Hall) as it appeared in 2014. It was constructed in the late 1920s and abandoned several years before Pennhurst's closure. Some efforts were made to have the building repurposed as a community arts center, but to no avail. The interior of the building has suffered from extensive vandalism. (Copyright © by Emery Roth II.)

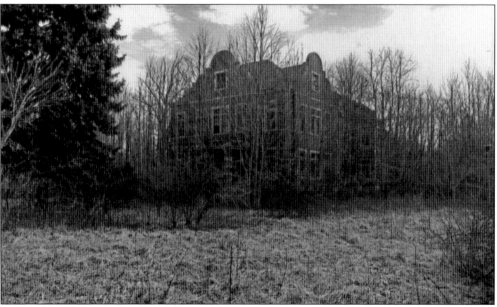

This is L Building (later renamed Limerick Hall). The facility's canteen (see page 37) was located on the first floor of L Building. The second floor was a residential area, and the third floor was initially used as staff quarters. It eventually became one of the more desirable client residences because the people living there had their own rooms. (Copyright © by John Bendel.)

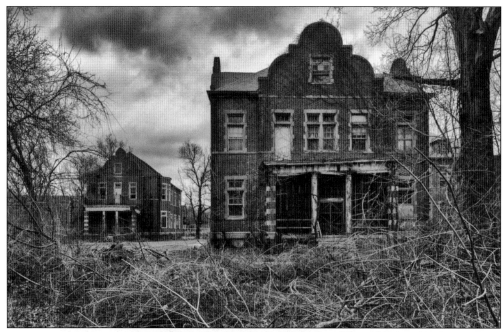

This 2014 image captures Mayflower Hall in the foreground, with the Philadelphia Building in the background. (Copyright © by Emery Roth II.)

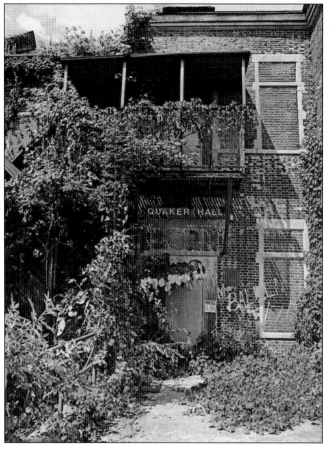

The front entrance to Quaker Hall is overgrown with weeds and climbing vines in this photograph from the summer of 2014. The author worked in Q Building for 7 of his 16 years at Pennhurst. (Copyright © by Thomas J. Neuville.)

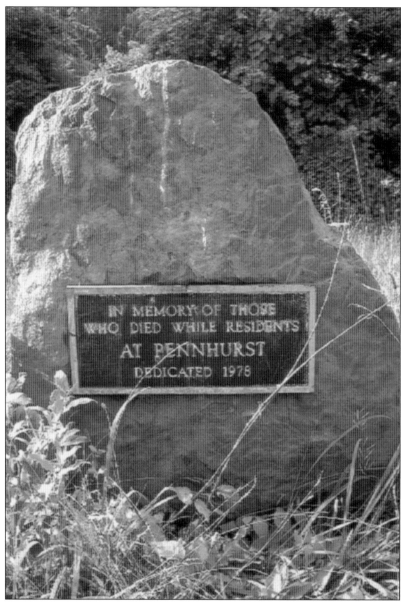

Like all state-operated institutions, Pennhurst had its own small cemetery. Many of the individuals buried there died in 1918, presumably victims of the influenza pandemic that swept the world that year. Burial in Pennhurst's cemetery, as with all institutional cemeteries, carried the last indignity, the last stroke of the dehumanization vested upon the facility's residents. The 40 graves in the Pennhurst cemetery had numbered markers only. The names of the individuals were not included on the small stones marking each grave. This changed in 1978 when, under the guidance of Ginny Thornburg, first lady of the Commonwealth of Pennsylvania, the markers were replaced with new stones that carried the names of each individual interred on the site. A large stone marker was erected at the same time to commemorate all the people who had died at Pennhurst, not just those buried on the grounds. Today, efforts similar to those undertaken at Pennhurst 35 years ago are under way to reclaim the identities of the people buried in institutional cemeteries across the country. (Photograph by Chris Peecho.)

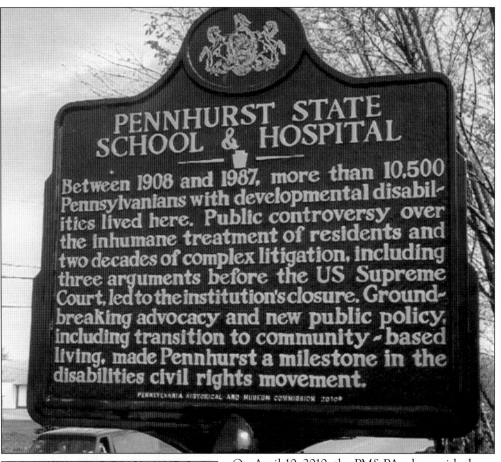

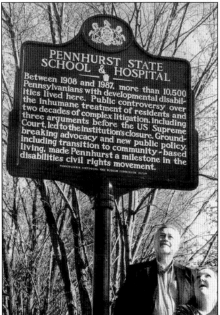

On April 10, 2010, the PM&PA, along with the Public Interest Law Center and the Pennsylvania Historical & Museum Commission, dedicated a highway marker on Route 724, adjacent to the Pennhurst campus in Spring City, Chester County. The marker acknowledges the lives of the people sent to Pennhurst and the national significance of the struggle that led to its closure.

PM&PA copresidents Dr. James Conroy and Jean Searle pose beneath the Pennhurst historical marker on the day that is was unveiled. This marker is believed to be the first erected in Pennsylvania commemorating the lives of institutionalized people and the fight for disability rights. The marker is located on Route 724 in East Vincent Township, Chester County. (Photograph by Craig Guest.)

Nathaniel Guest addresses the audience during the April 10, 2010, dedication ceremony for the Pennhurst historical marker. Fittingly, the ceremony was held at the Spring Hollow Golf Course, which is located on a portion of Pennhurst's farm property. Guest was one of the founders of PM&PA. (Photograph by Craig Guest.)

PM&PA copresident Jean Searle speaks to the crowd gathered to witness the unveiling of the highway marker. Searle lived in an institution for a decade. Since moving out, she has dedicated her life to assuring that all people are provided with the opportunity to enjoy life in the community. For the last 20 years, she has been employed as a policy advocate for the Disability Rights Network of Pennsylvania. (Photograph by Craig Guest.)

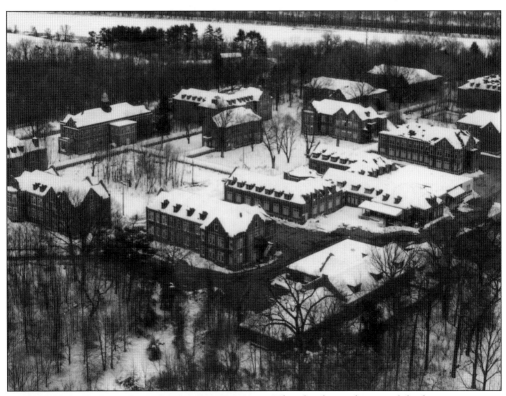

This final aerial view of the historic Pennhurst campus was taken during the filming of *A Call of Conscience*, a video funded by PM&PA and created by Heath Hofmeister of Electric Machine Productions. The video can be found on the PM&PA website. (Copyright © by Marc Reed.)

The logo of PM&PA incorporates a sculpted dogwood blossom. These beautiful sculptures encircle the front doors of the administration building.

About the Pennhurst Memorial & Preservation Alliance

The Pennhurst Memorial & Preservation Alliance (PM&PA) was founded in 2008. It had two goals from the beginning: to remember the people of Pennhurst and to encourage the preservation and reuse of the campus. The board has developed formal mission and vision statements to further these goals. They are as follows:

> The mission of the Pennhurst Memorial & Preservation Alliance is to promote an understanding of the struggle for dignity and full civil rights for persons with disabilities, using the little-known history at Pennhurst. By sharing this tragic story as well as its landmark victories, we seek to educate citizens in local, national, and international communities, to assure that we never go back. The vision of the Pennhurst Memorial & Preservation Alliance is to be part of an effort to create a world-class national museum to honor and memorialize the ongoing civil and human rights struggle of Americans with disabilities in a location of national significance, to assure that we never go back.

The group's mission was highlighted with these thoughts during the unveiling of the Pennhurst marker in 2010:

> It is important that we remember what society did to people who were viewed as 'different' from the rest of us. Accepting that our brothers and sisters with disabilities were somehow different allowed us to accept for decades the conditions of custodial neglect and warehousing that characterized Pennhurst and similar institutions across the country. It is important that we also remember that the fight of people with disabilities to achieve their full rights is ongoing. While the worst conditions of institutionalization are largely gone, in America today, people with disabilities are more likely to live in poverty than other citizens; they are more likely to be the victims of crime and abuse than others; they are more likely to be unemployed or underemployed than others; they are more likely to be placed unnecessarily in a nursing home rather than be supported in their own community. The fight that brought us to this point needs to be remembered. The fight that remains needs to be acknowledged.

DISCOVER THOUSANDS OF LOCAL HISTORY BOOKS
FEATURING MILLIONS OF VINTAGE IMAGES

Arcadia Publishing, the leading local history publisher in the United States, is committed to making history accessible and meaningful through publishing books that celebrate and preserve the heritage of America's people and places.

Find more books like this at
www.arcadiapublishing.com

Search for your hometown history, your old stomping grounds, and even your favorite sports team.